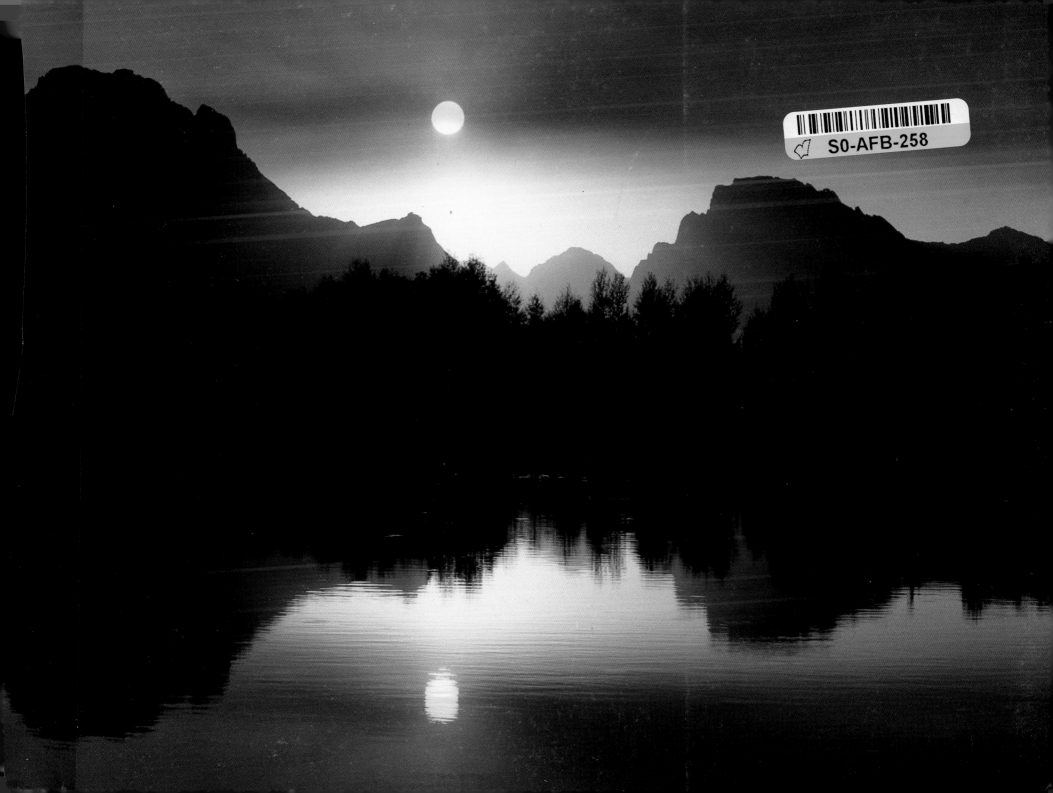
SO-AFB-258

THE ROCKY MOUNTAINS

LA SALLE BRANCH LIBRARY
3232 W. ARDMORE TRAIL
SOUTH BEND, INDIANA 46628

This book has been
withdrawn from the
St. Joseph County Public Library
due to

___deteriorated defective condition

___obsolete information

___superceded by newer holdings

___excess copies / reduced demand

___last copy

___other_____

9.16.98 Date DM_____ Staff

THE ROCKY MOUNTAINS

WILDLIFE IN THE HIGH COUNTRY

74.978 Y83r LAS
oshino, Shin
he Rocky Mountains

SHIN YOSHINO

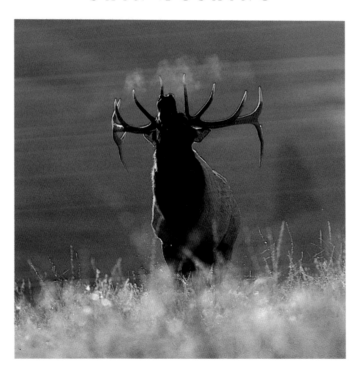

CHRONICLE BOOKS

SAN FRANCISCO

PUBLIC LIBRARY
MAY 1 5 1995
SOUTH BEND, INDIANA

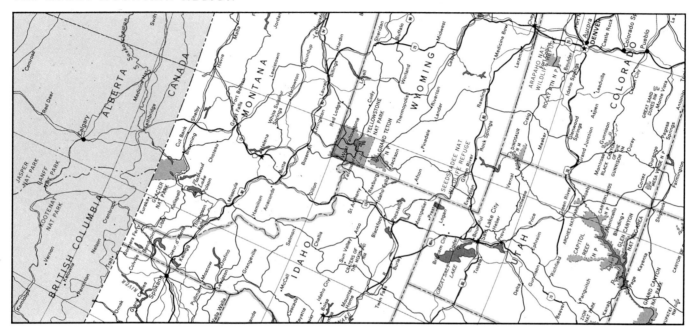

Map courtesy of U.S.G.S.

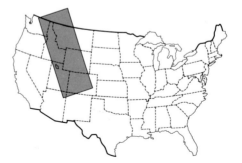

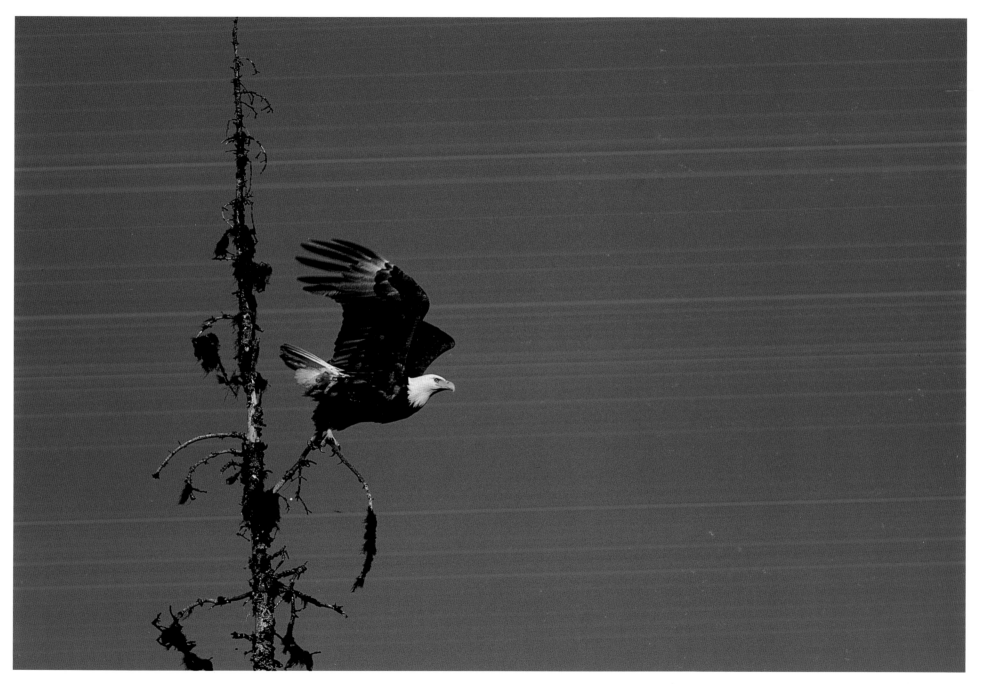

3

Kootenay National Park, British Columbia

A bald eagle, its eyes already seeking prey, launches itself into the clear mountain sky.

4

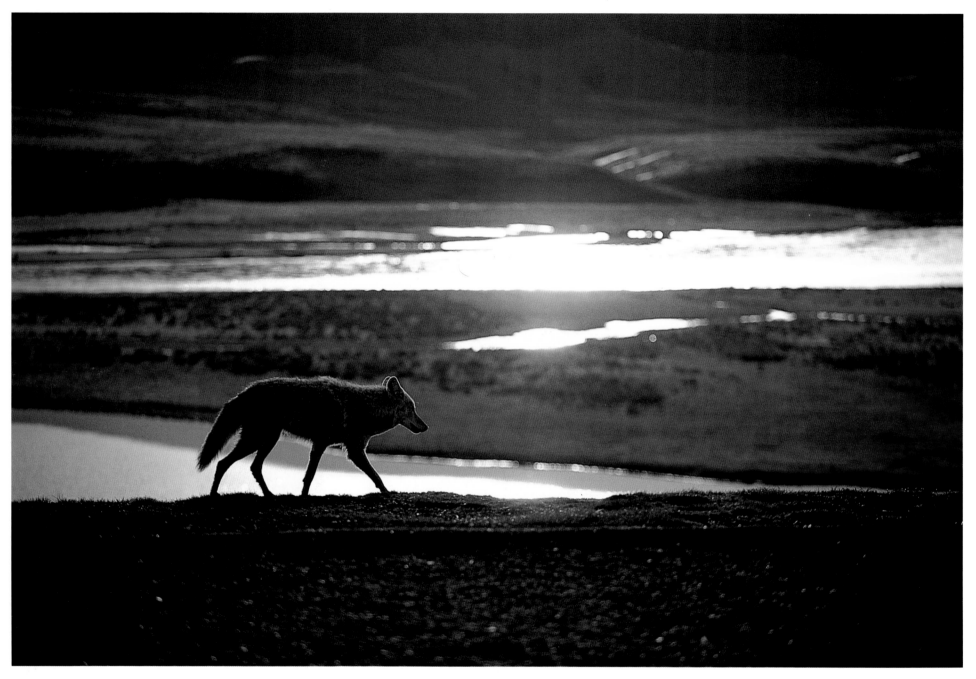

Adaptable and resourceful, the coyote covers a vast range in search of food.

Yellowstone National Park

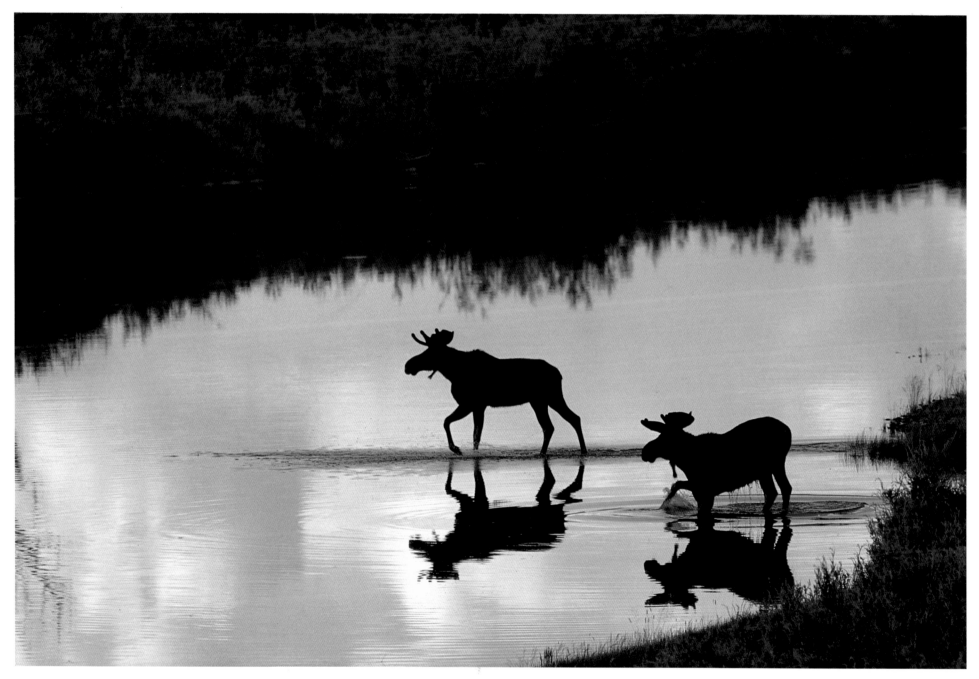

5

Seedskadee National Wildlife Refuge Young male moose cross a river in the glow of late evening, their reflections shimmering on the water's surface.

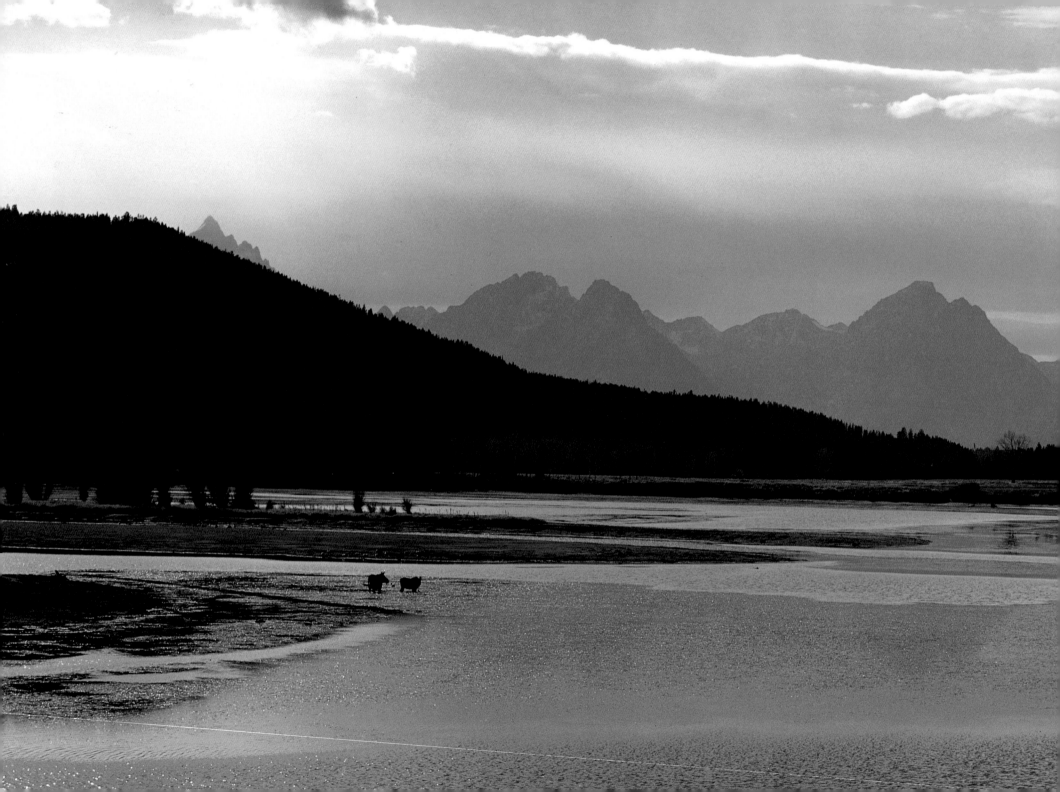

< *Grand Teton National Park*
Two moose wade quietly in the waters below the Teton Mountains.

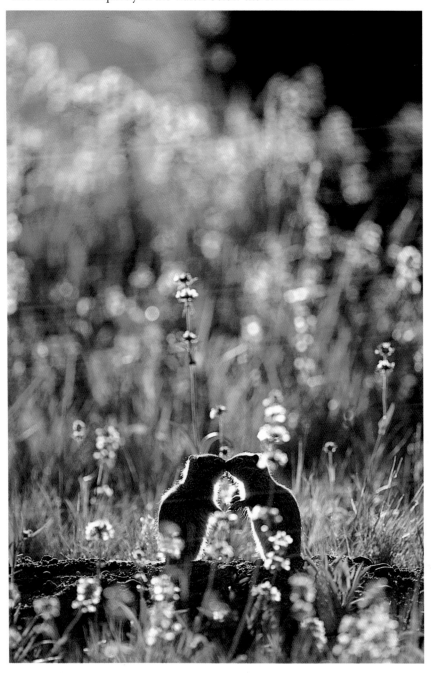

Yellowstone National Park After romping in a field of flowers, these
ground squirrels pause before returning to their nest.

8

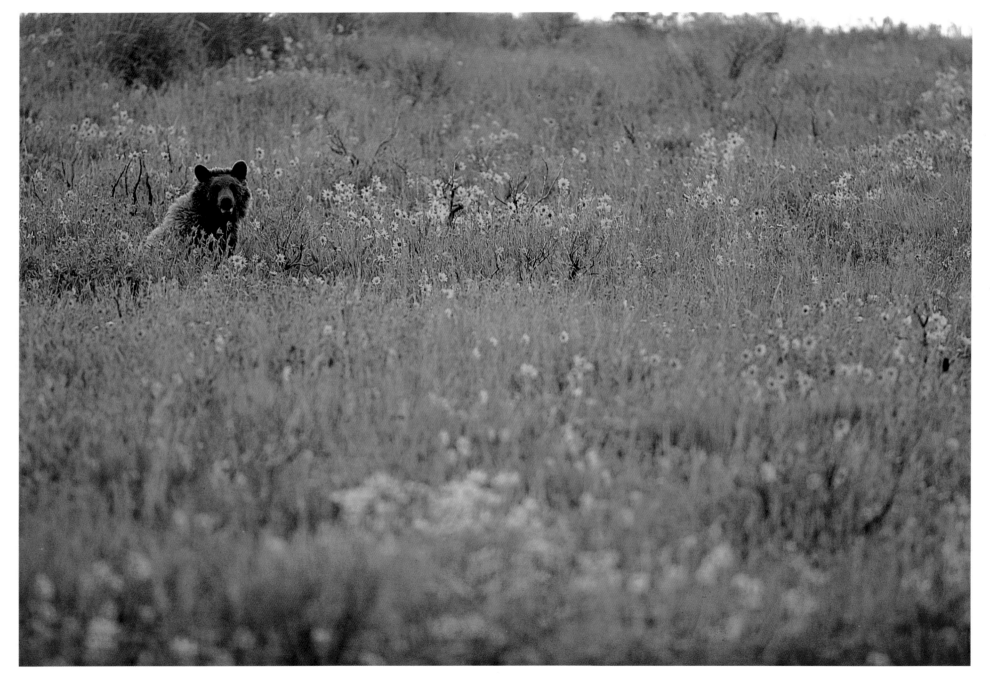

The size and power of this lone grizzly bear stand in stark contrast to this delicate field of flowers.

Yellowstone National Park

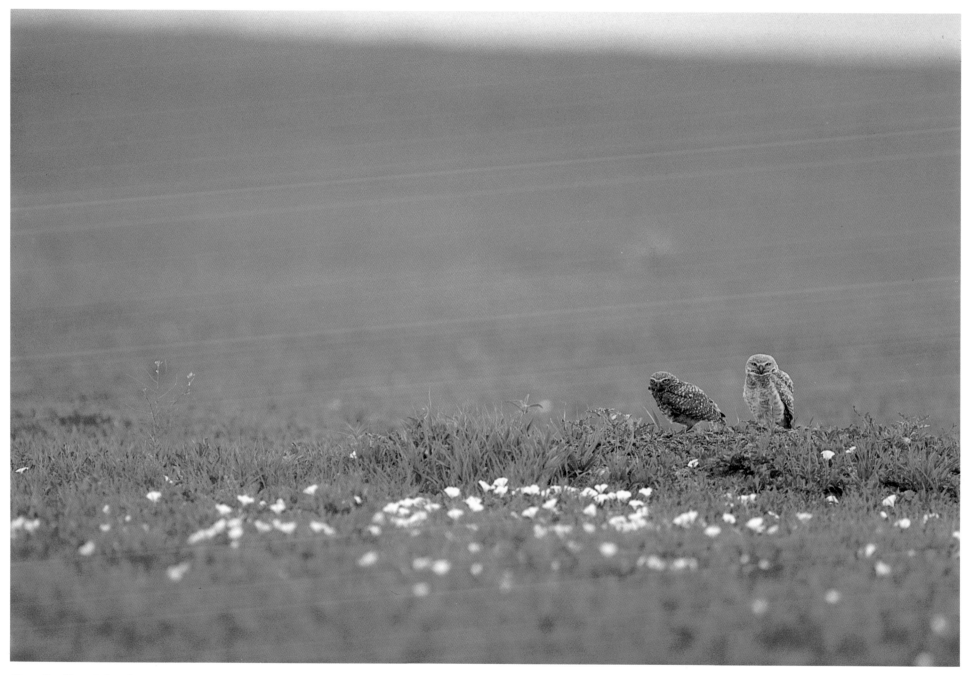

Near Boulder, Colorado

Burrowing owls often take over abandoned prairie dog holes for use as nests.

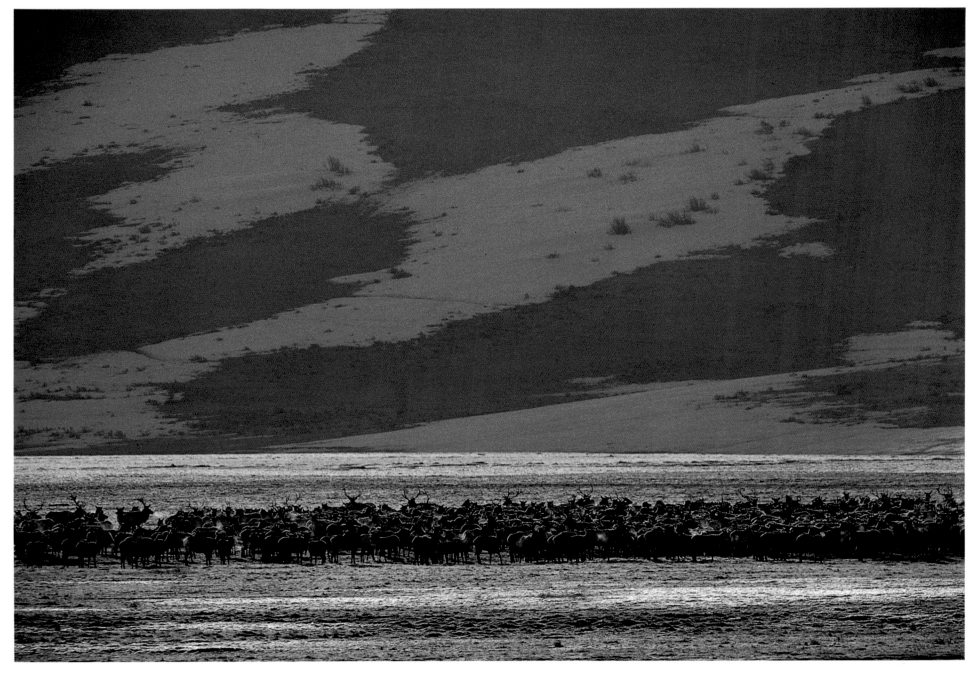

Known to the Indians as *Wapiti*, elk are large, gregarious deer who like to travel in herds.

National Elk Refuge

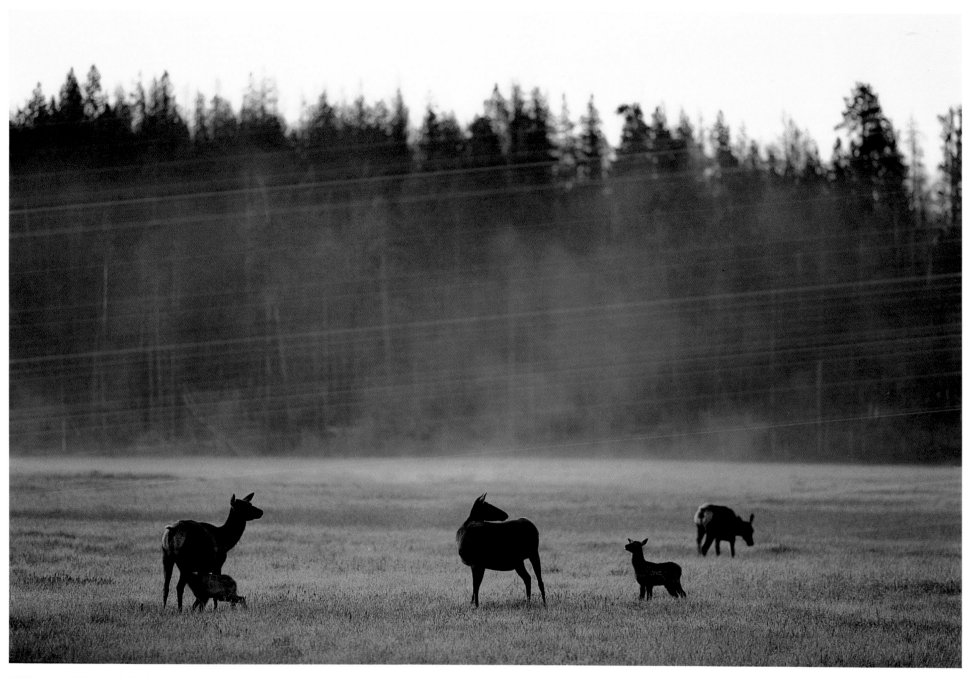

Yellowstone National Park

As the morning mist evaporates, an elk fawn takes its nourishment the easy way.

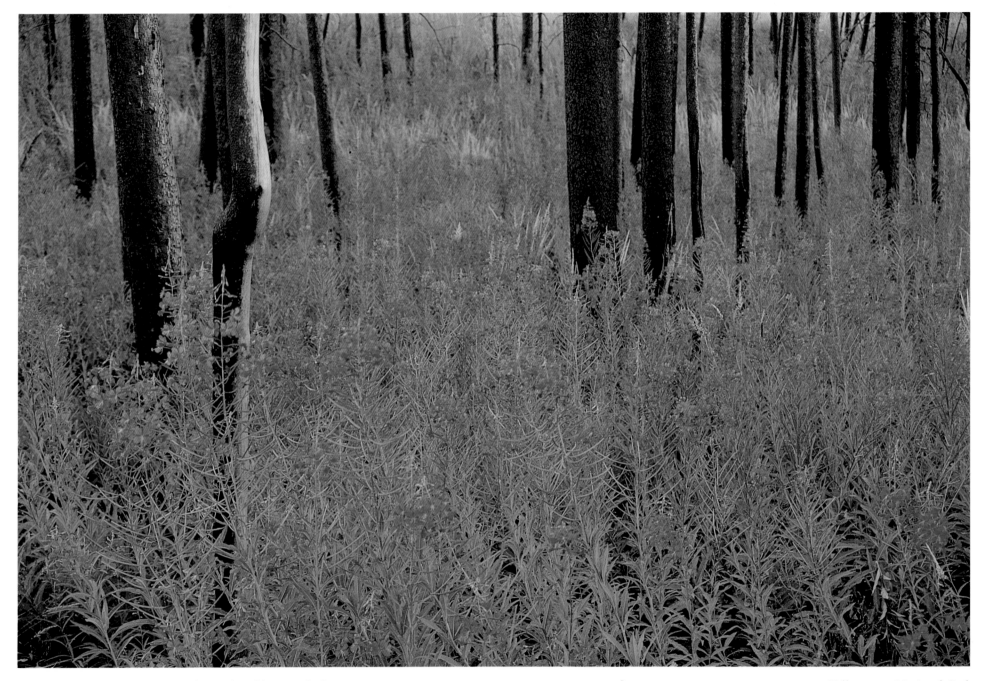

12

Fireweed bloom in summer amid the trunks of fire-scorched trees.

Yellowstone National Park

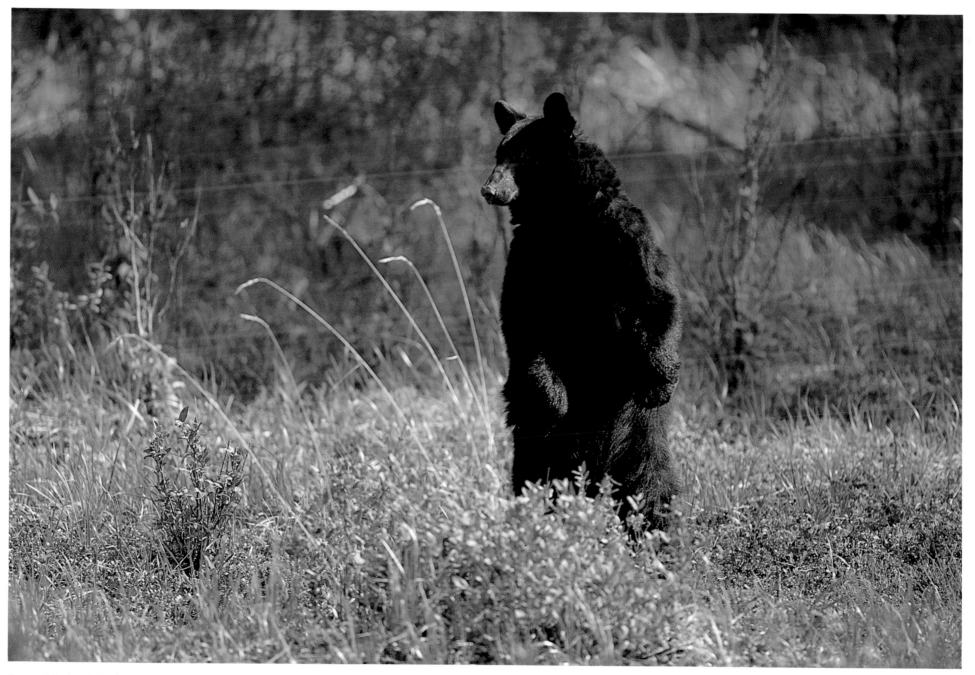

Jasper National Park

The omnivorous black bear is forever foraging for insects, plants, and small animals.

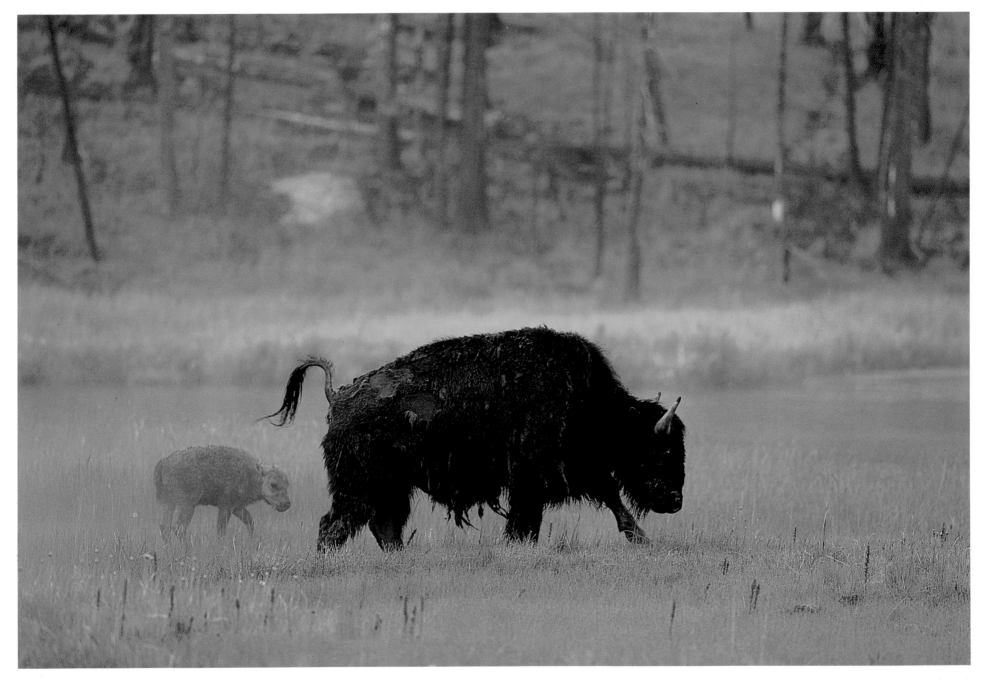

14

Hunted nearly to extinction in the last century, bison are now protected in several western refuges.

Yellowstone National Park

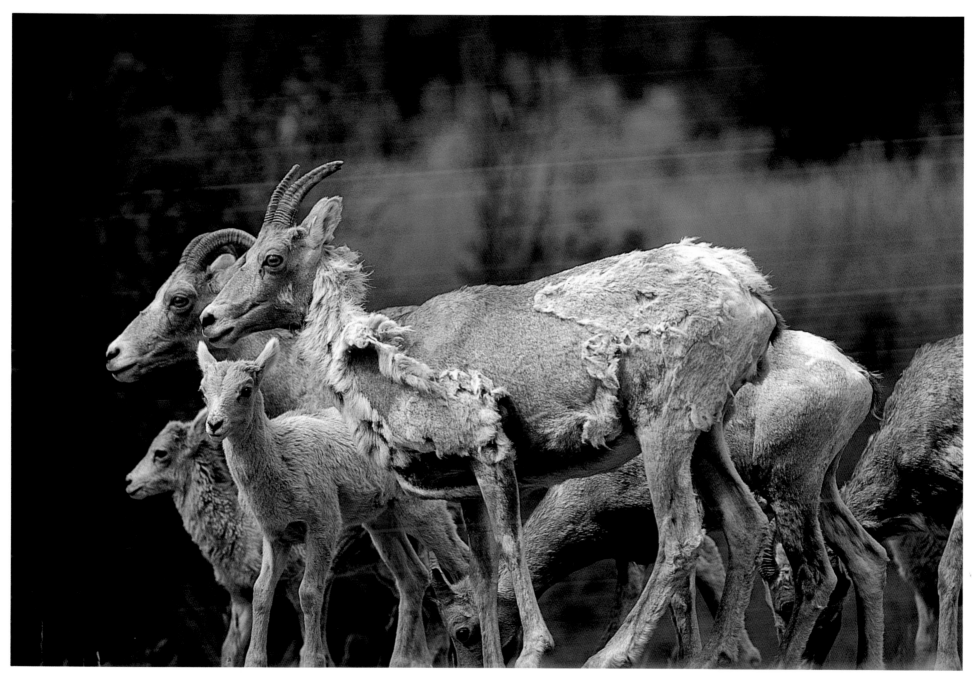

Banff National Park

These bighorn sheep are shedding their heavy winter coats in preparation for the coming summer.

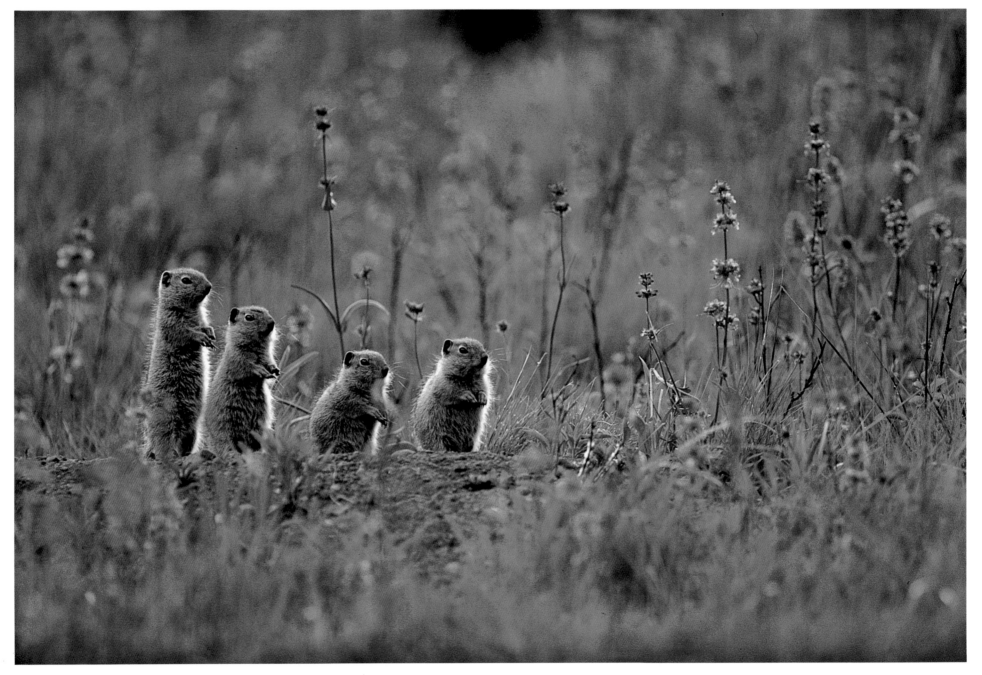

Taking a break from cleaning their nests, these ground squirrels all adopt the same pose as they examine something that has caught their attention. *Yellowstone National Park*

16

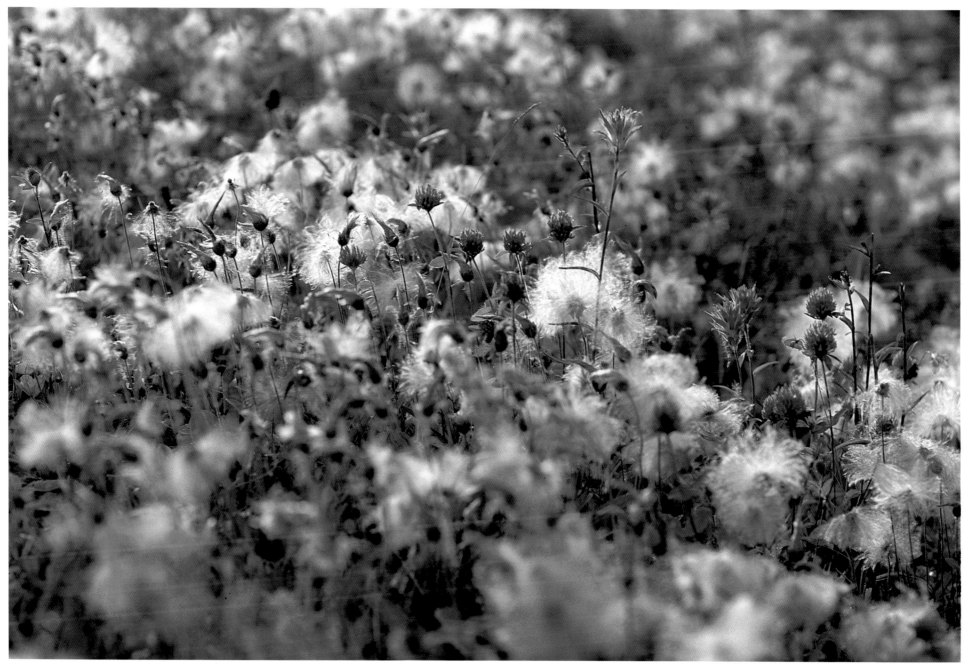

17

Jasper National Park

Cotton grass makes a white backdrop for a multicolored carpet.

Bison warily regard a group of coyotes in the slanting rays of early morning sunlight.

Yellowstone National Park

Arapaho National Wildlife Refuge

The badger, a tough and remarkable digger, is rarely seen during the daylight hours.

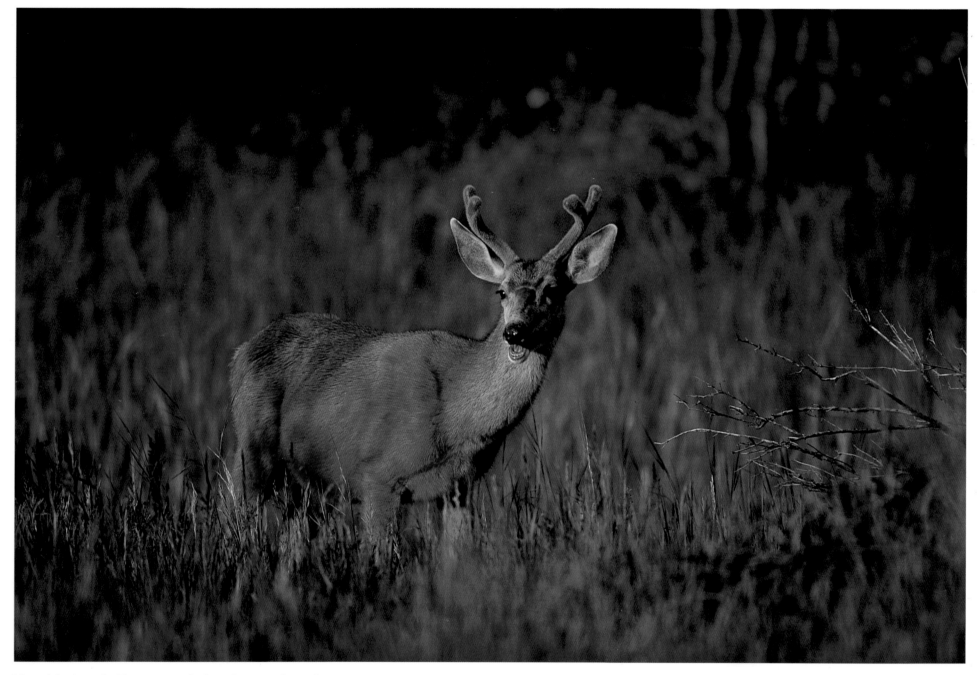

Named for its mule-like ears, a mule deer glances at the setting sun.

Yoho National Park

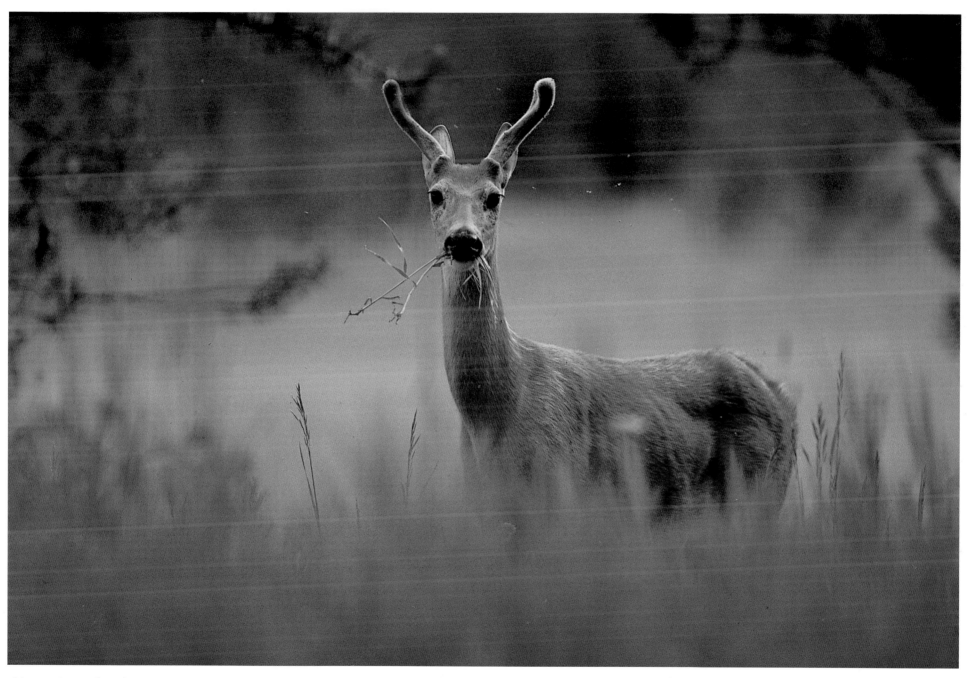

21

A young white-tailed deer munches quietly while warding off insects by flapping its ears.

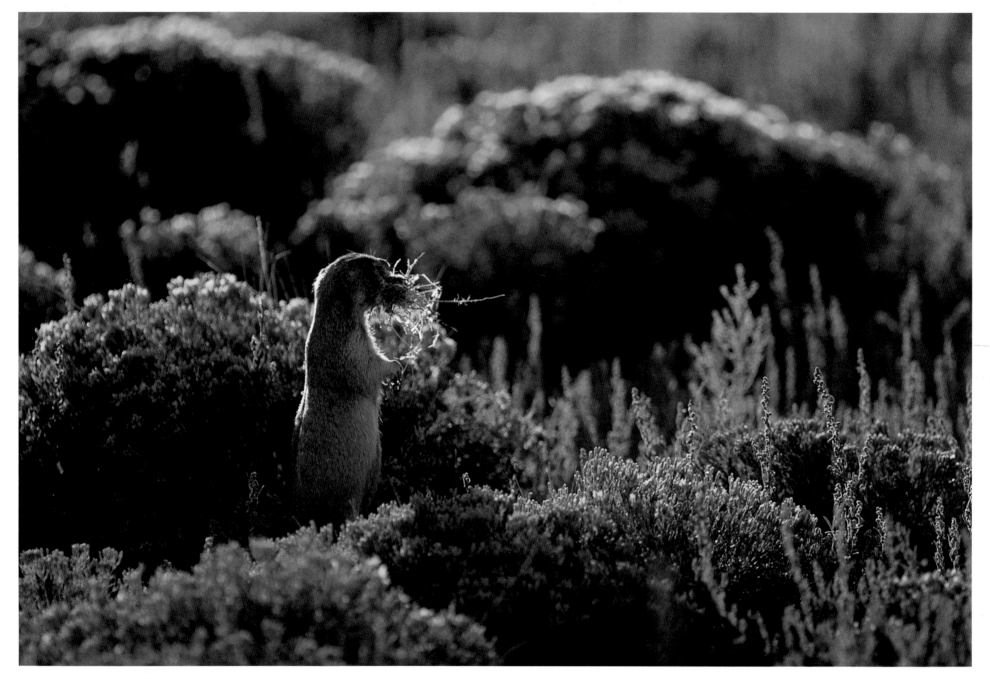

22

The black-tailed prairie dog constructs elaborate burrows stretching over hundreds of feet.

Arapaho National Wildlife Refuge

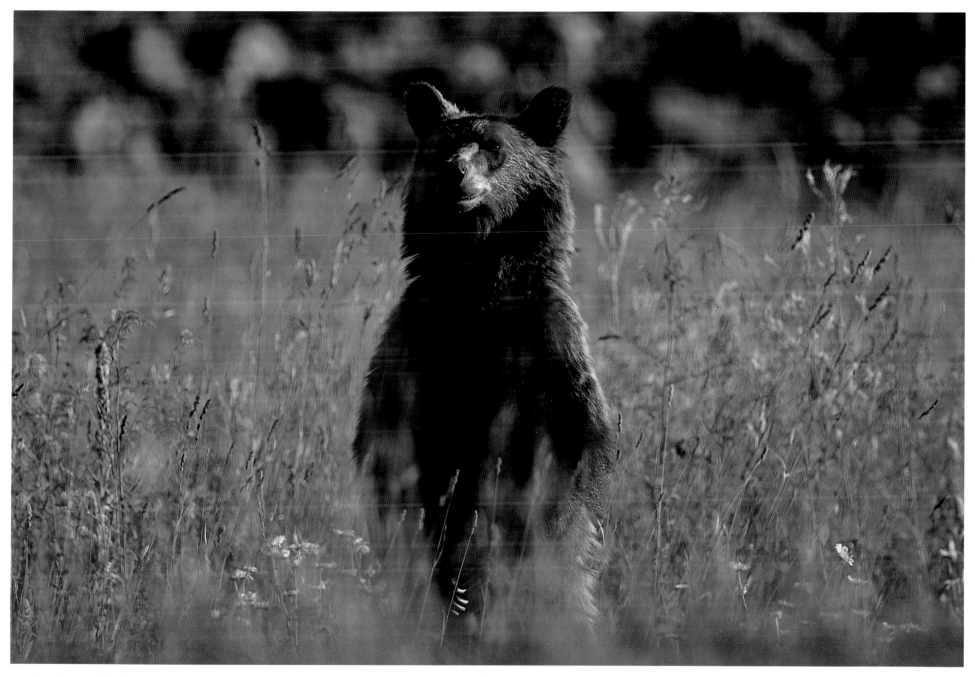

23

Glacier National Park

Standing upon its hind legs for a better view, the grizzly bear is an imposing sight.

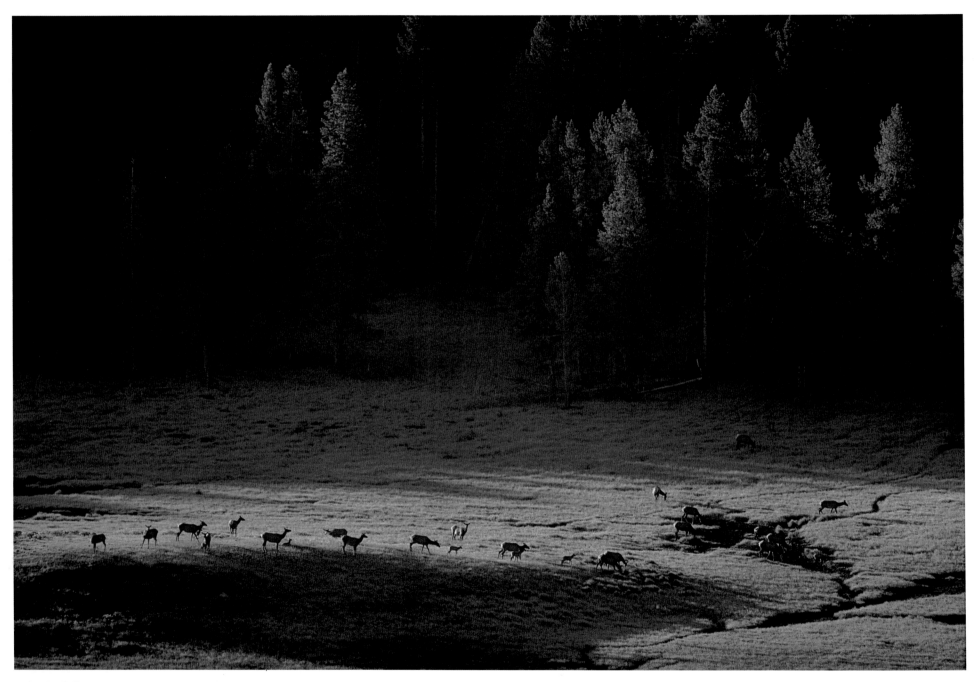

A herd of elk grazes in a mountain meadow.

Yellowstone National Park

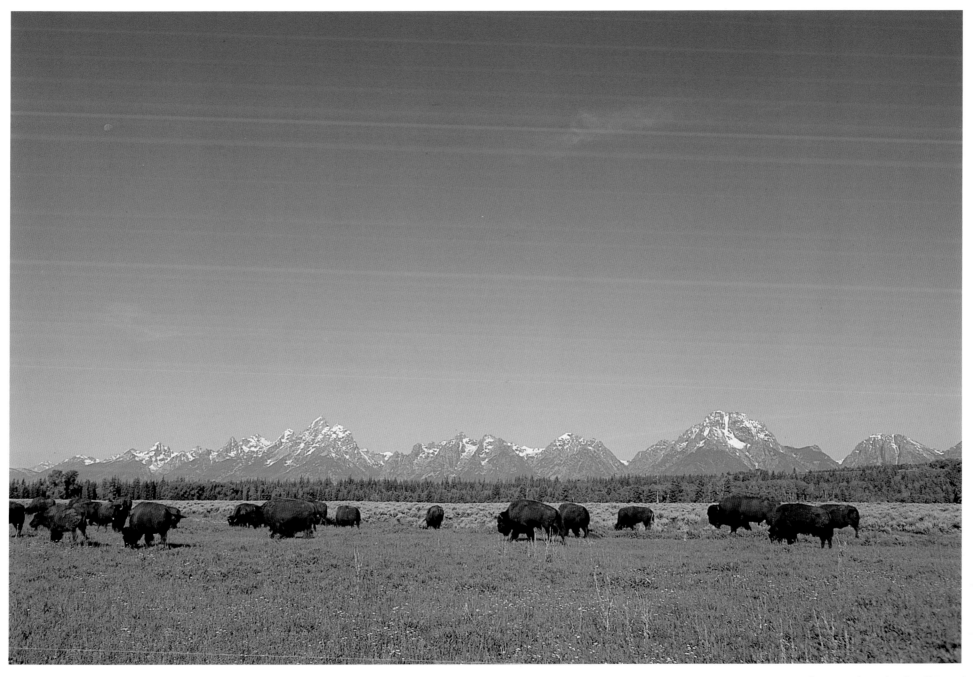

Grand Teton National Park

The Tetons are home to large herds of bison.

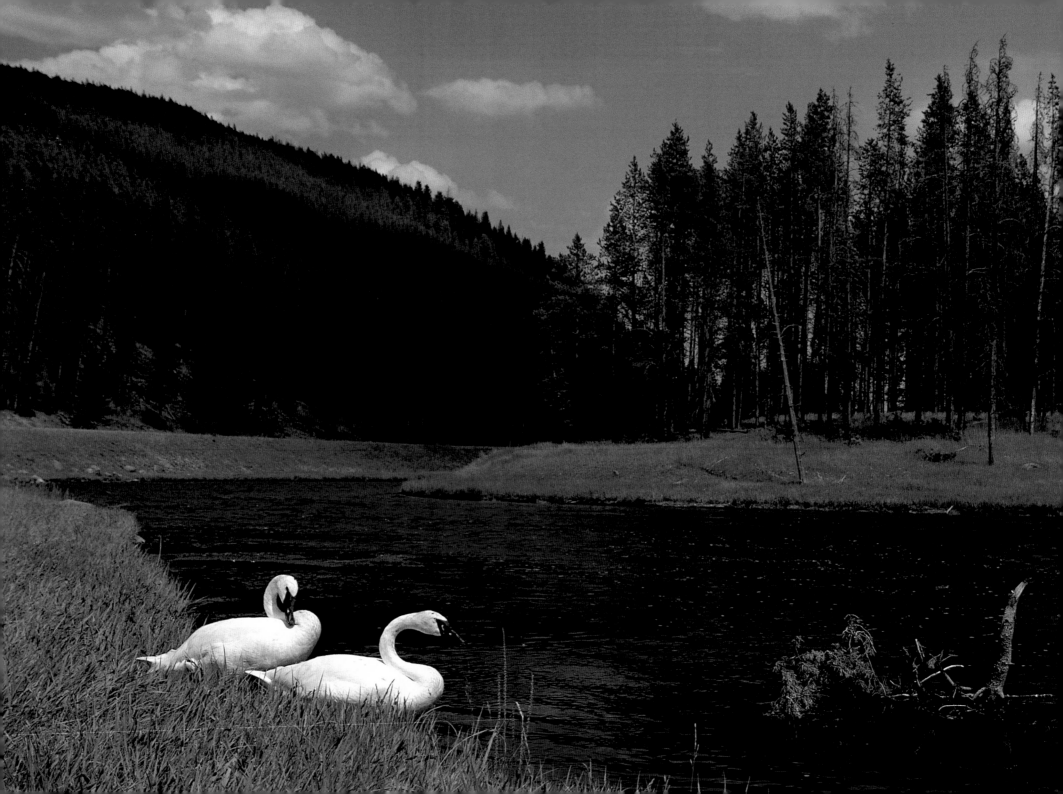

< *Yellowstone National Park*
These trumpeter swans were among the earliest arrivals in the spring.

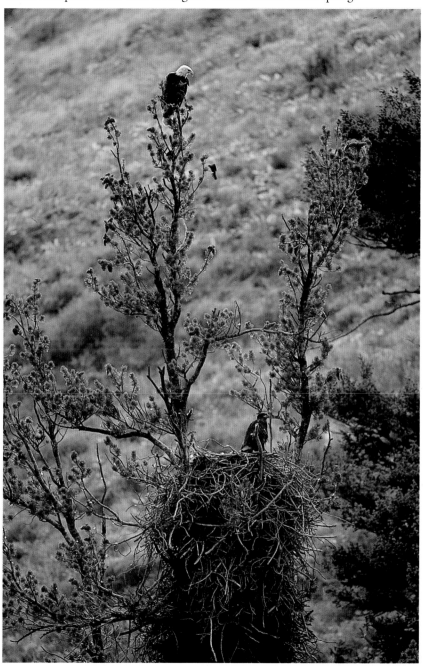

Near Jackson Hole, Wyoming A bald eagle watching over its fledgling
is harried from below by a small intruder.

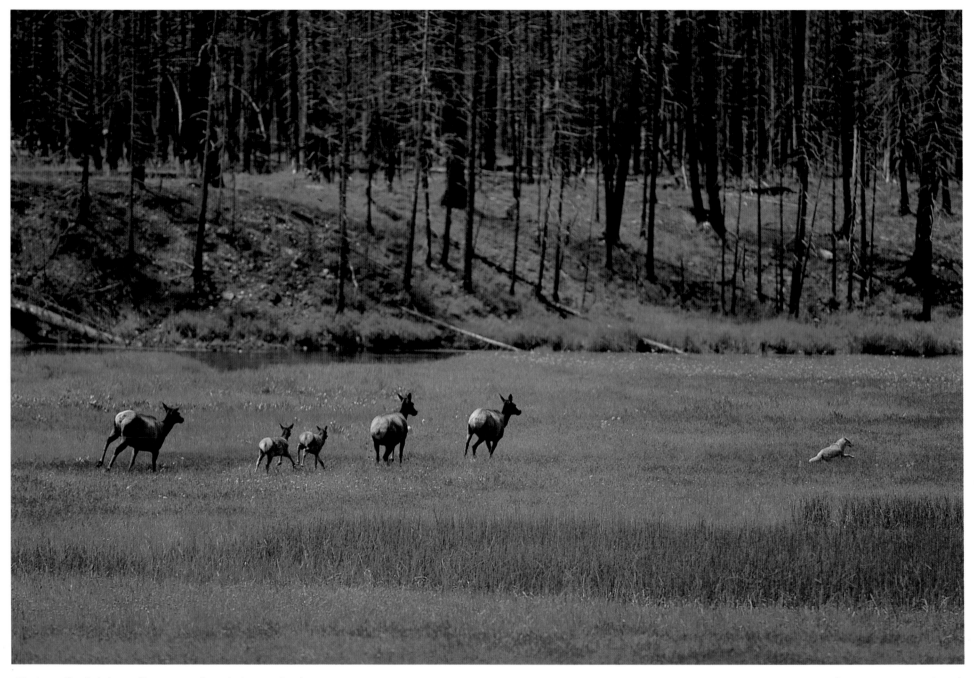

Having offended these elk, a coyote flees their pursuing hooves.

Yellowstone National Park

29

Focused and intent, this coyote has spied a likely meal.

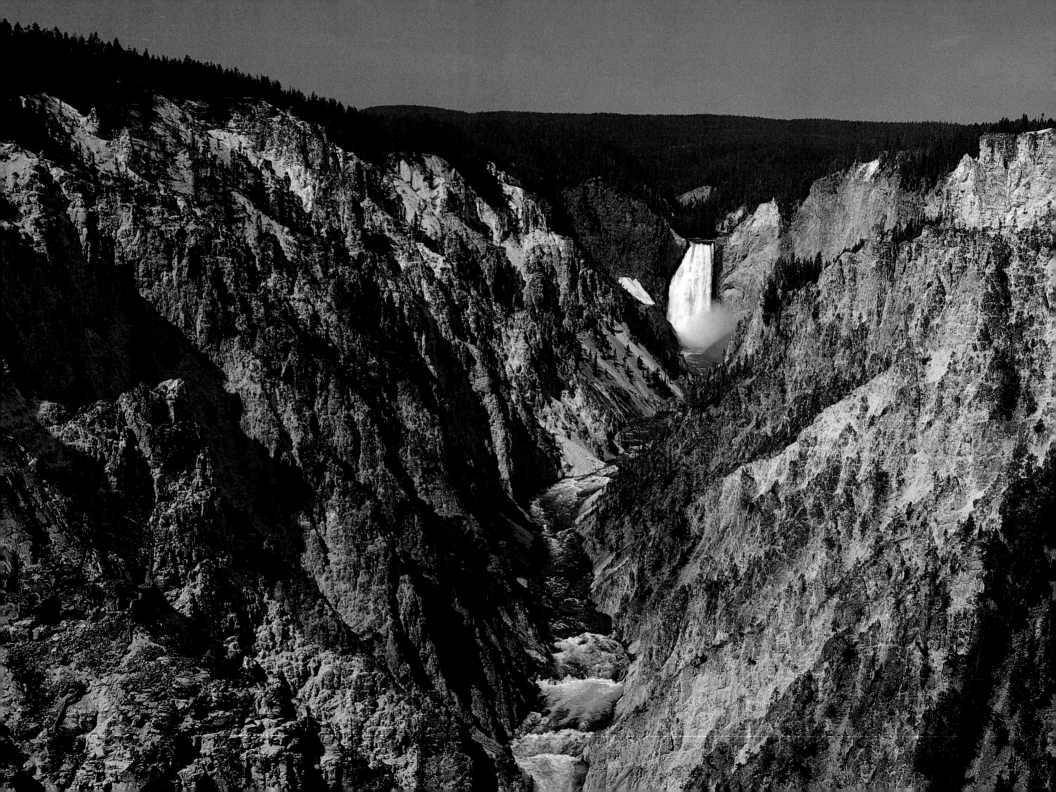

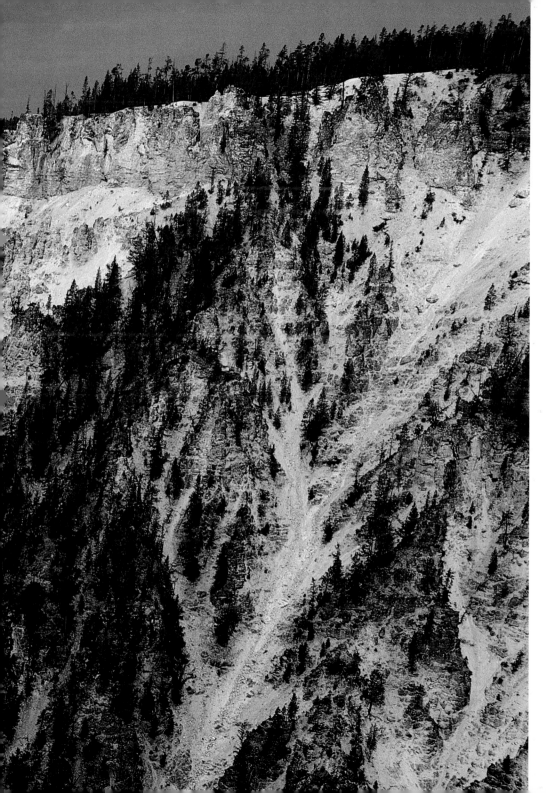

< *Yellowstone National Park*
The Grand Canyon of the Yellowstone, a slice through the mountain granite.

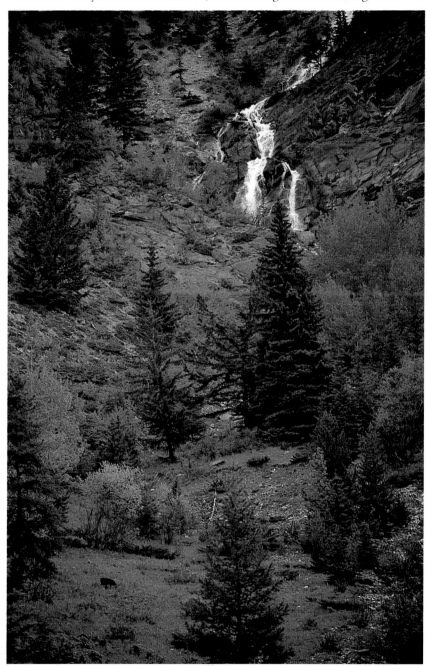

Banff National Park Below a cascading creek, a black bear
makes its way through the forest.

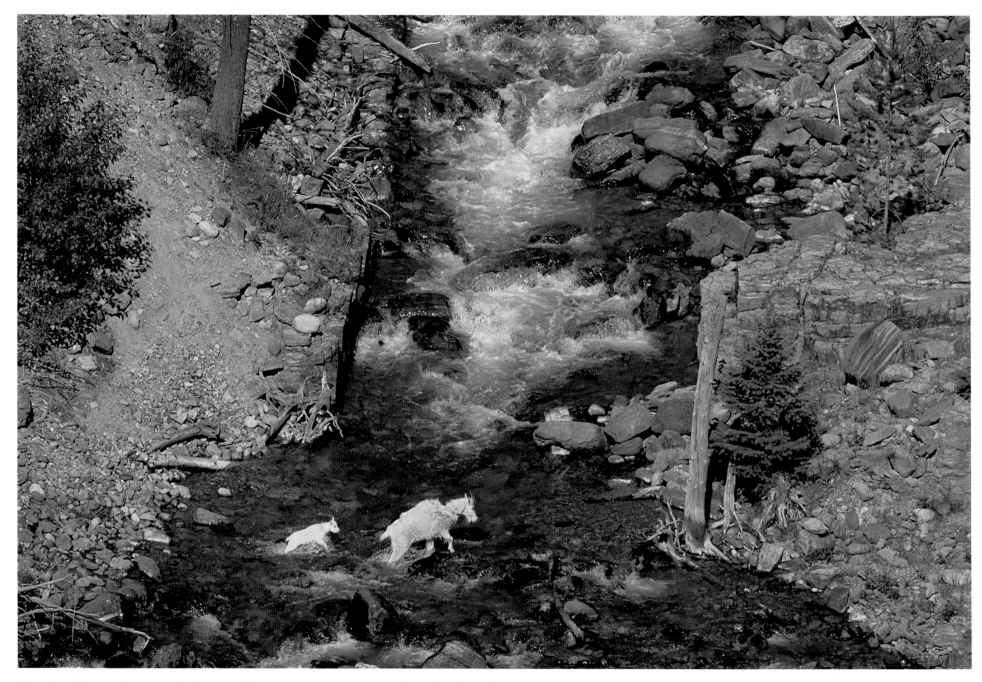

32

Crossing a fast-running stream is dangerous for young mountain goats, so the mother shows the way.

Jasper National Park

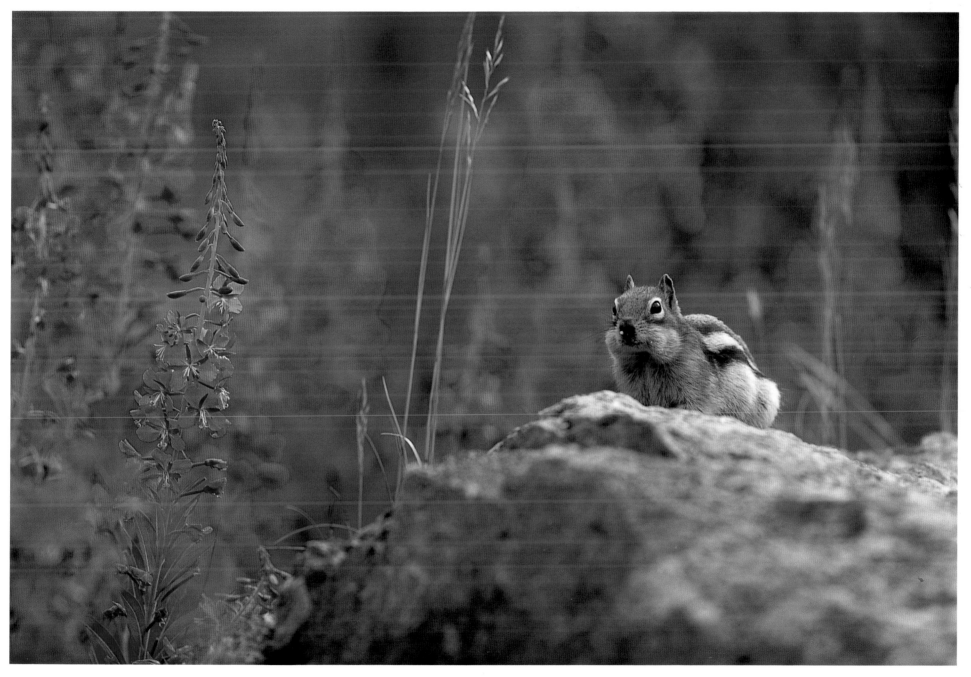

33

Surrounded by fireweed, a gold-mantled ground squirrel peers over the edge of a large rock.

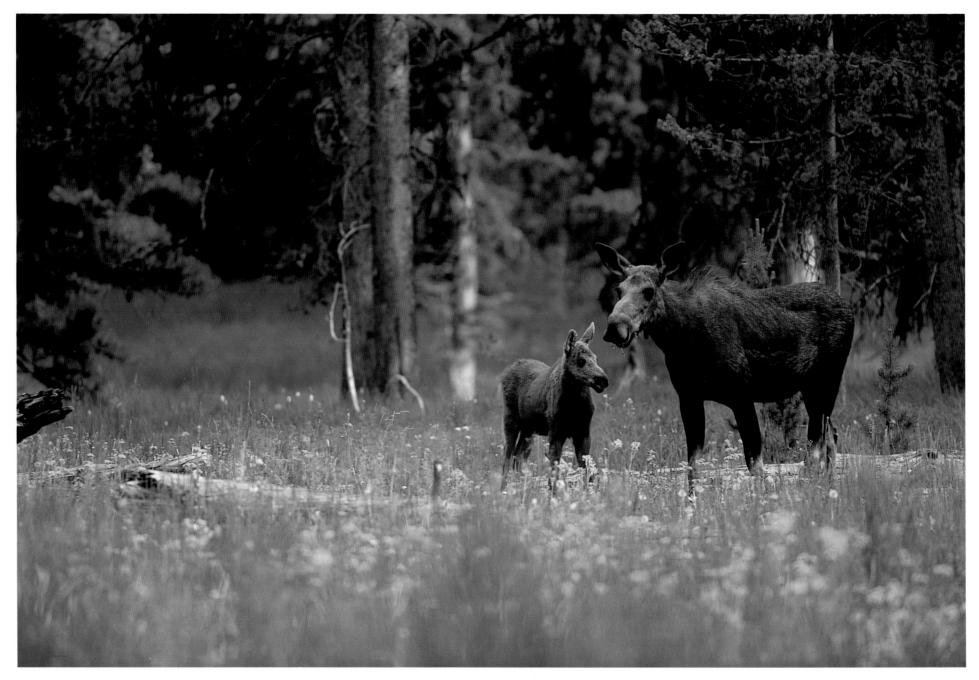

A mother moose and her young pause for a quiet moment together.

Yellowstone National Park

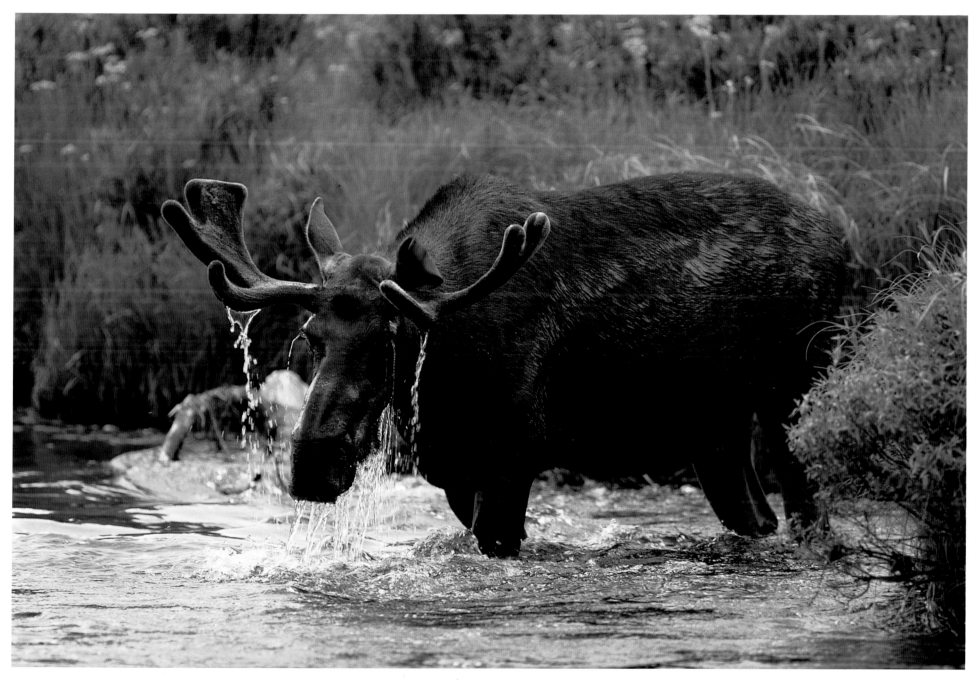

Yellowstone National Park

Water streams off the head of this male moose, which has been searching the creek bottom for plants.

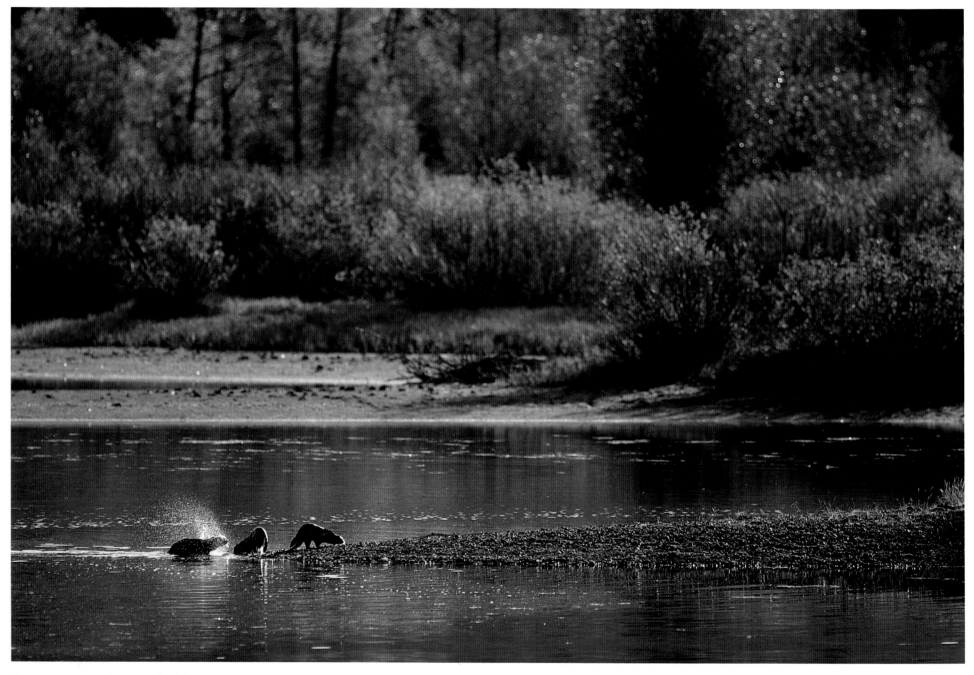

Otters are among the most playful creatures in the wild. These Canadian river otters shake themselves after climbing out of the water.

Grand Teton National Park

Grand Teton National Park

Ever industrious, the beaver makes constant improvements to its lodge.

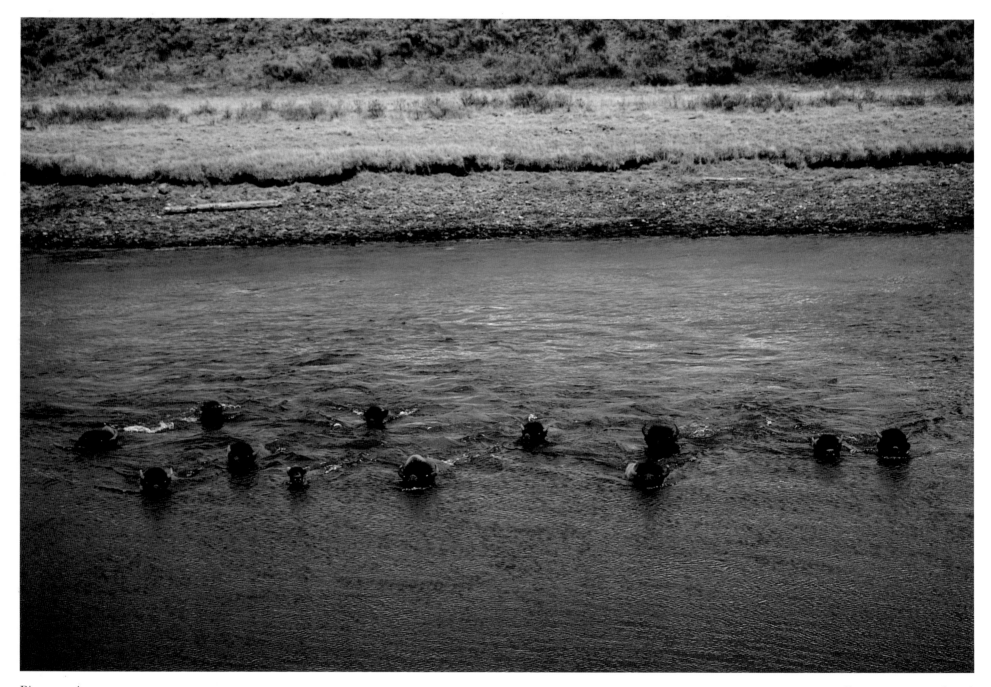

Bison crossing a stream.

Yellowstone National Park

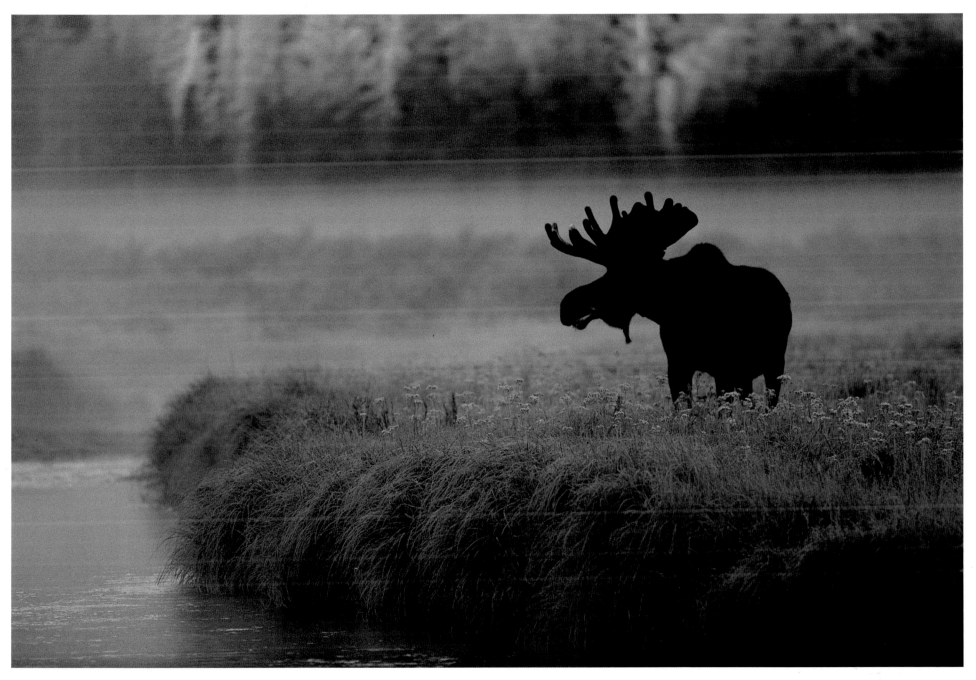

39

Yellowstone National Park

Early morning mist rises behind a feeding moose.

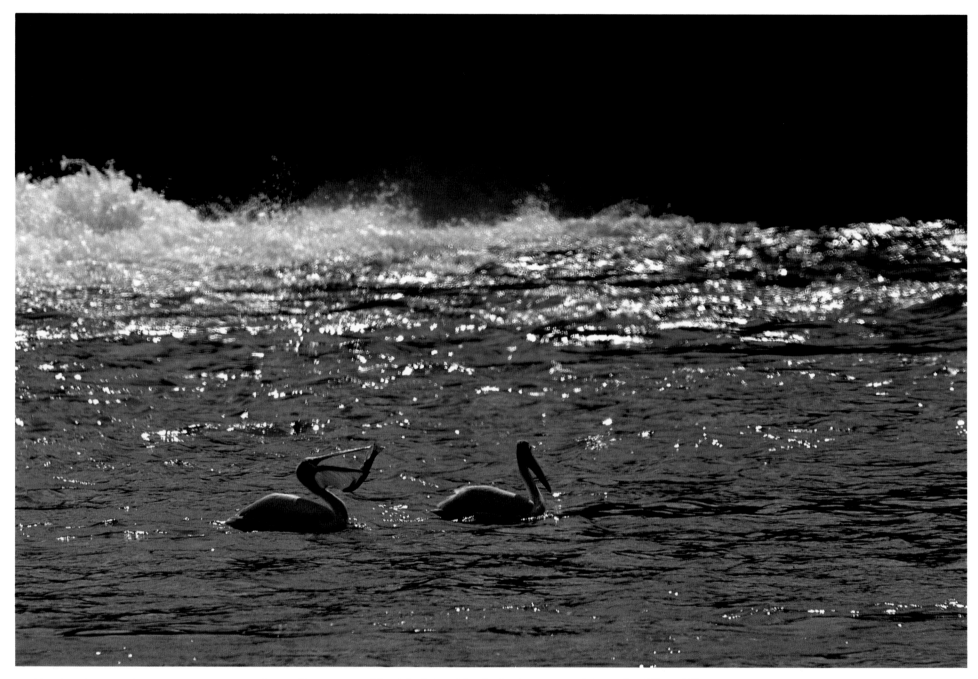

40

Unlike their brown pelican cousins, American white pelicans cannot fish while flying. Like ducks, they pursue their meals while paddling.

Grand Teton National Park

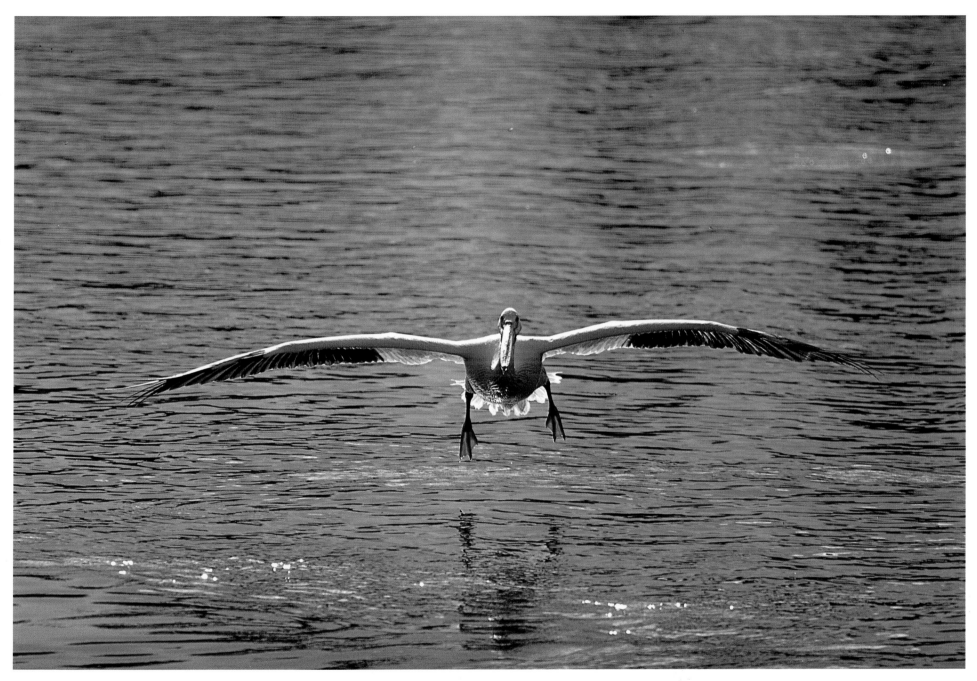

Yellowstone National Park The American white pelican is a deft flyer, its grace unaffected by its large body and beak.

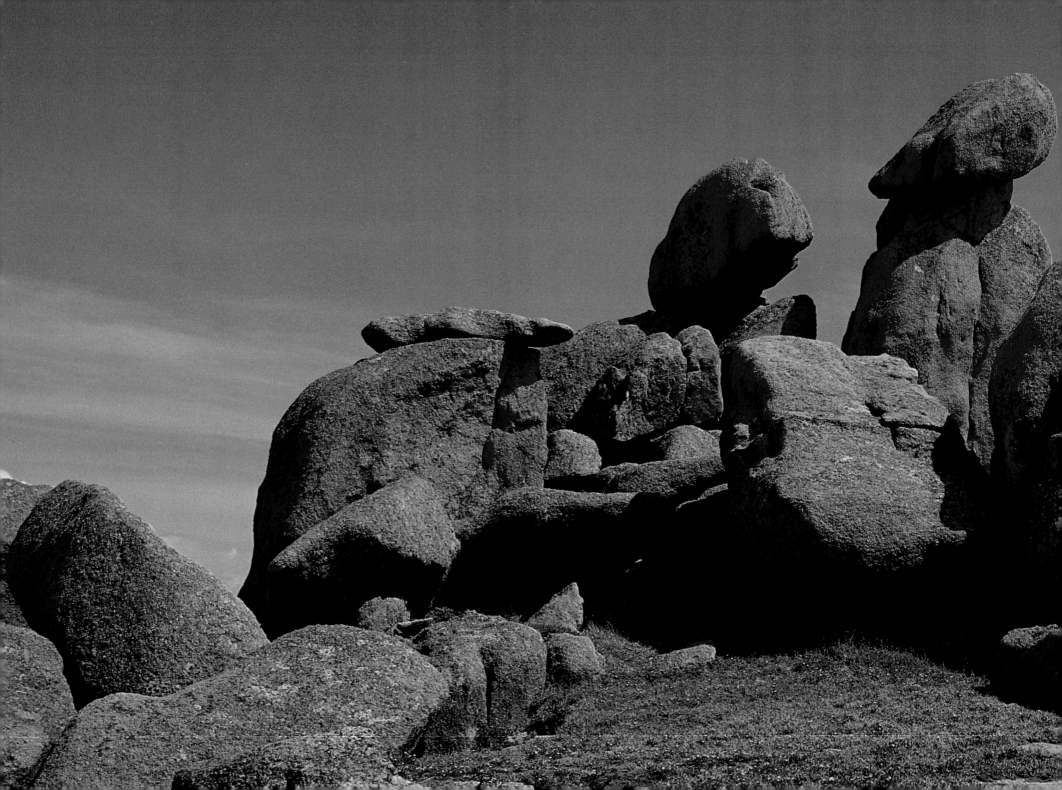

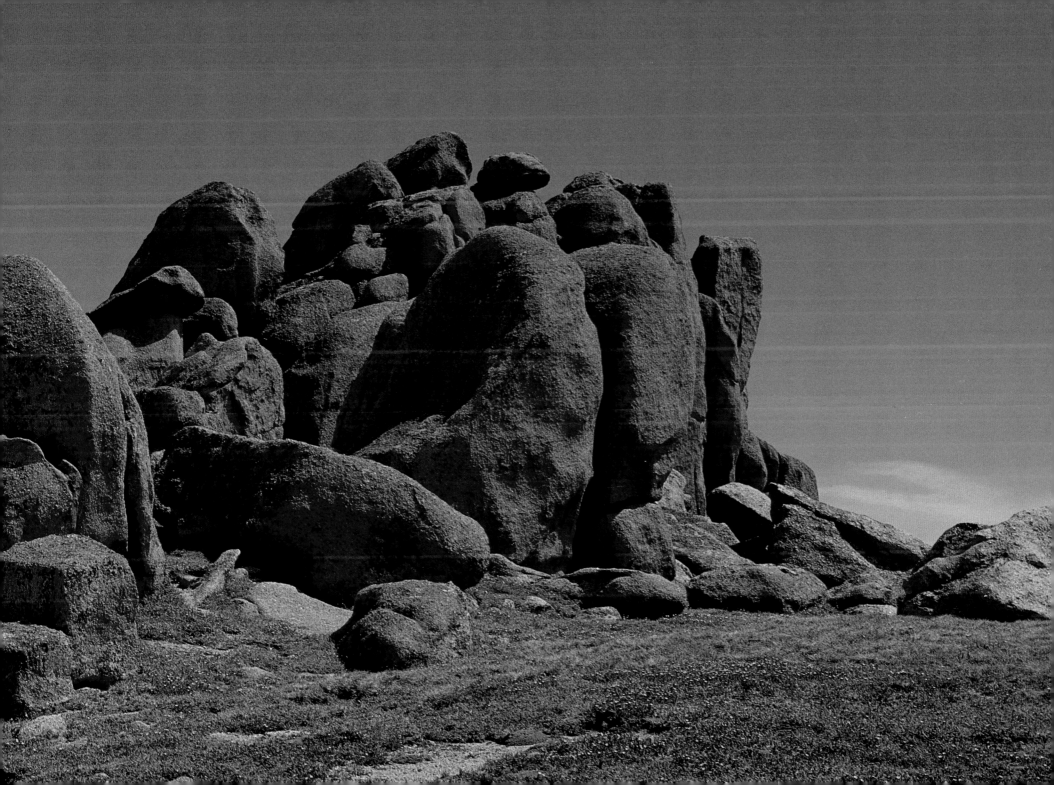

44

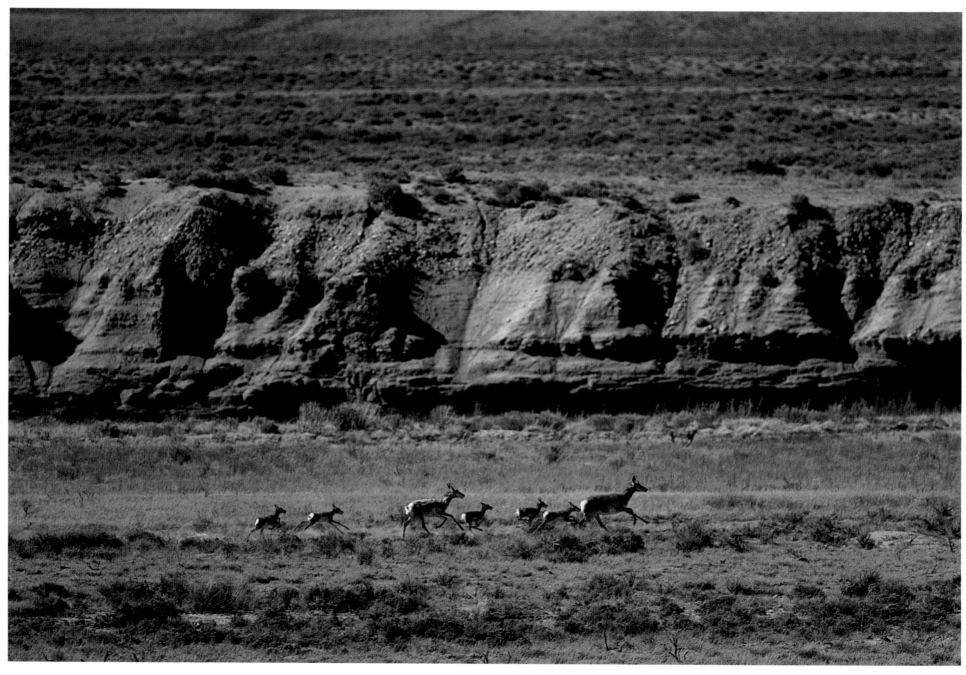

Pronghorns race across the plains.

Seedskadee National Wildlife Refuge

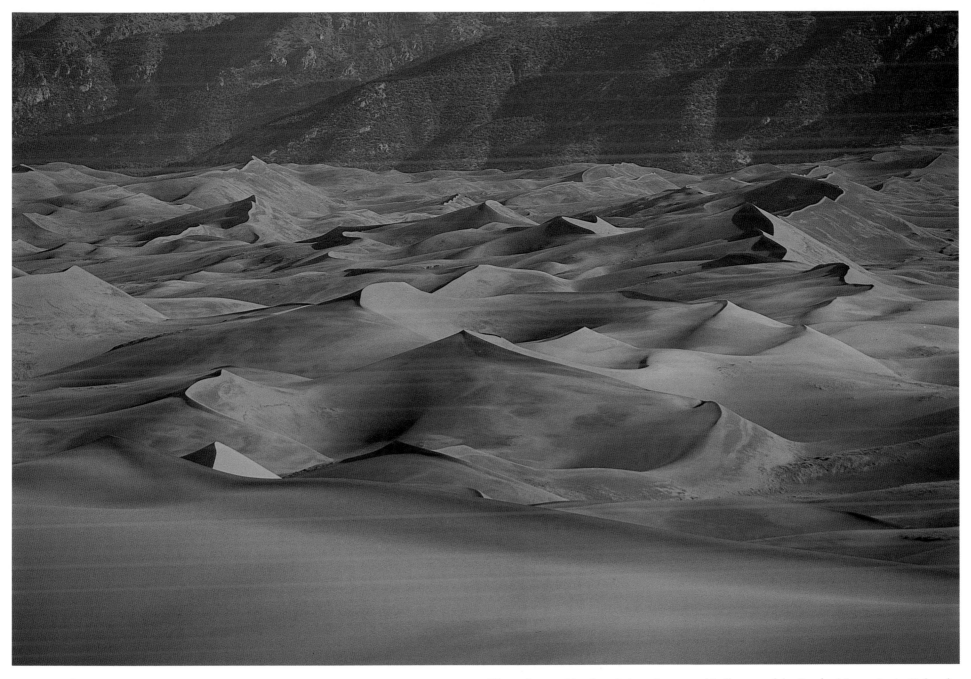

45

Great Sand Dunes National Monument

These short swirls of sand, though geographically part of the Rocky Mountains in Colorado, seem to have no relation to the high peaks just a short distance to the north.

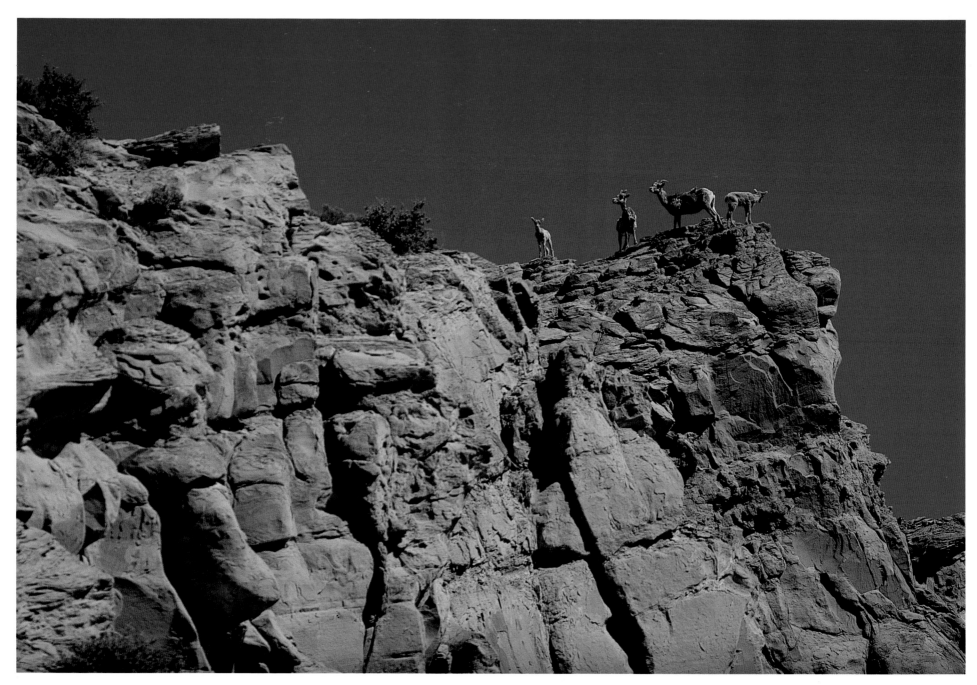

46

Bighorn sheep are at home on the heights.

Yellowstone National Park

47

Pikes Peak, Colorado The social yellow-bellied marmots usually post one of their number as a sentry to warn of approaching danger.

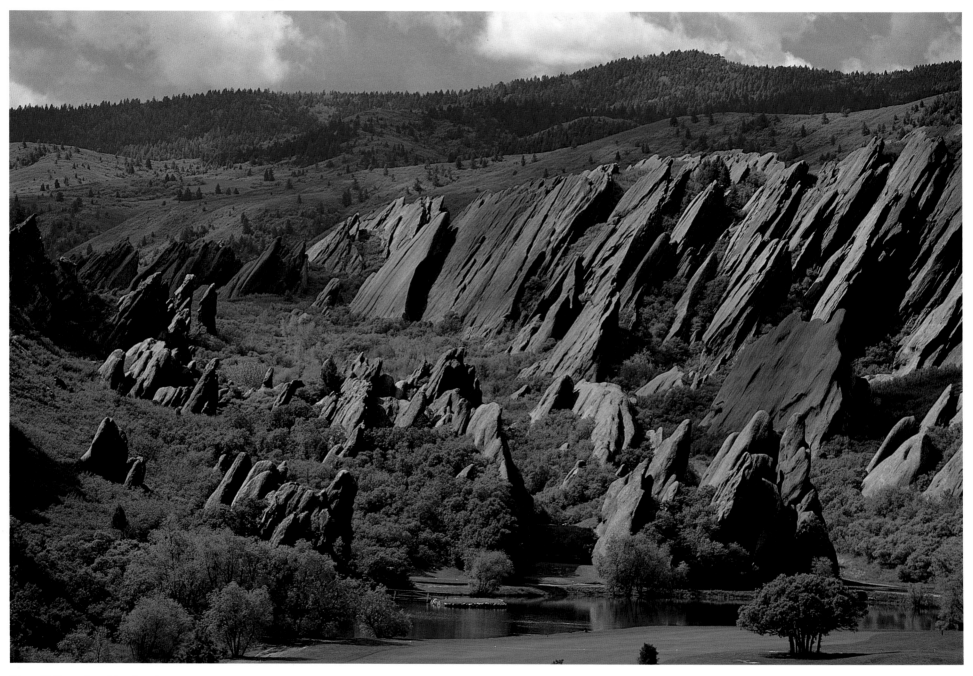

48

Beautifully sculpted by the elements.

Near Denver, Colorado

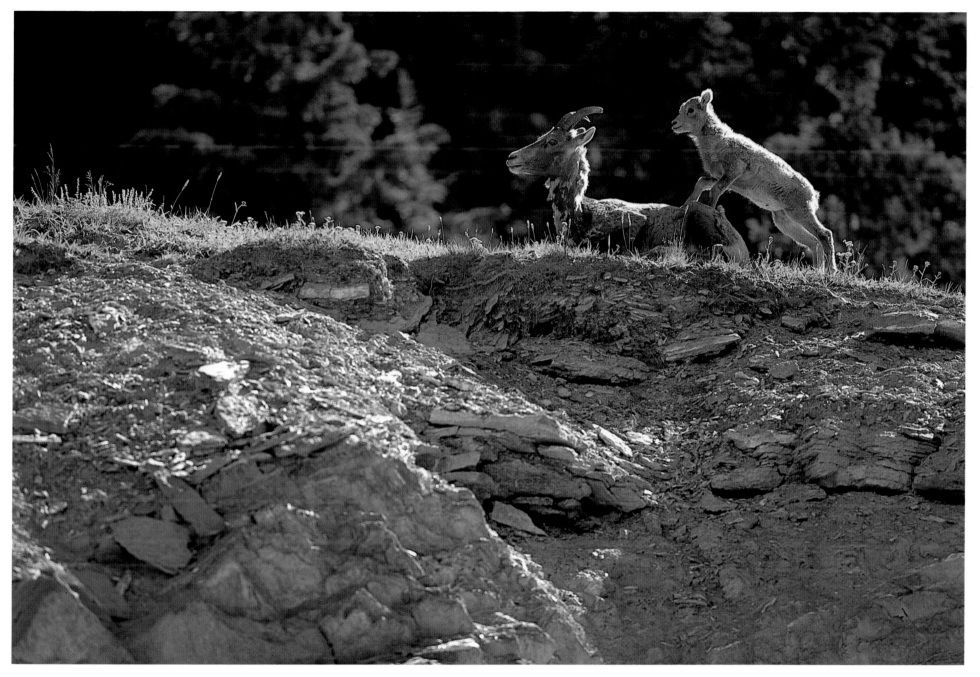

Banff National Park

Young bighorn sheep often play by jumping straight up onto a rock, or their mother's back.

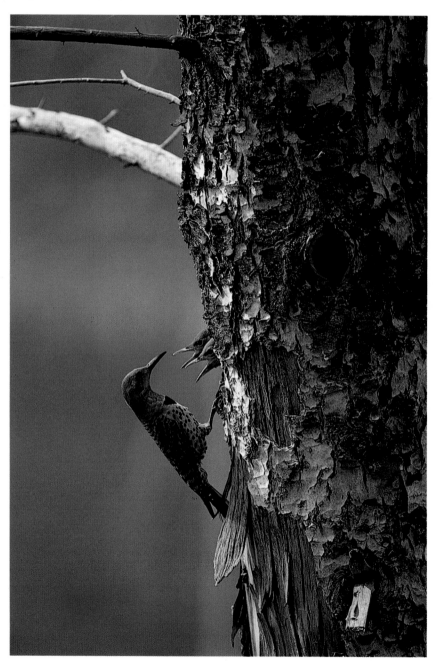

50

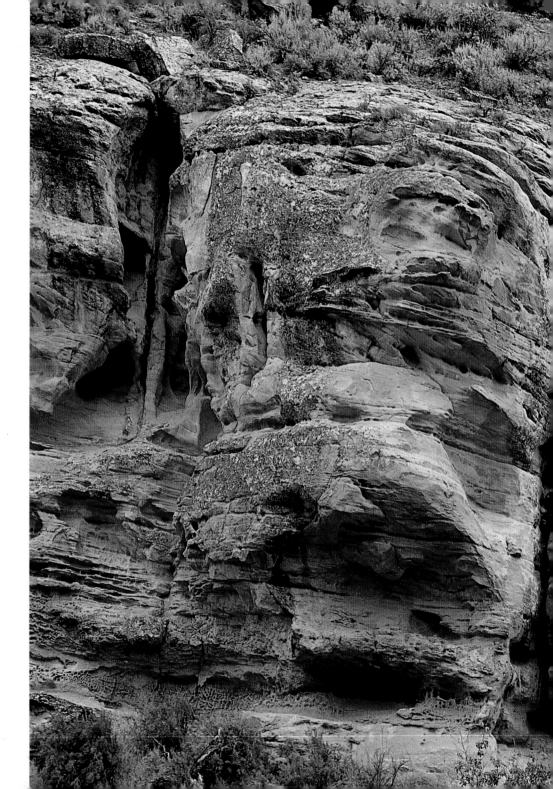

Quake Lake, Montana A common flicker returns to the nest
to be greeted by the hungry beaks of its young.

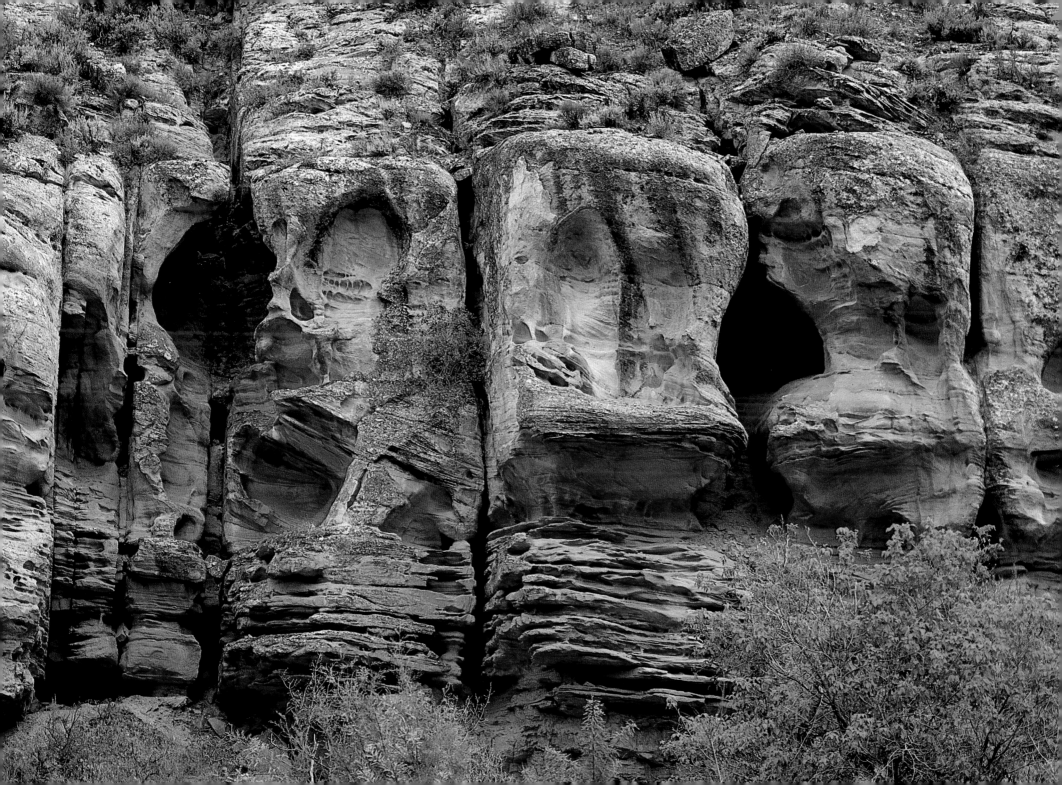

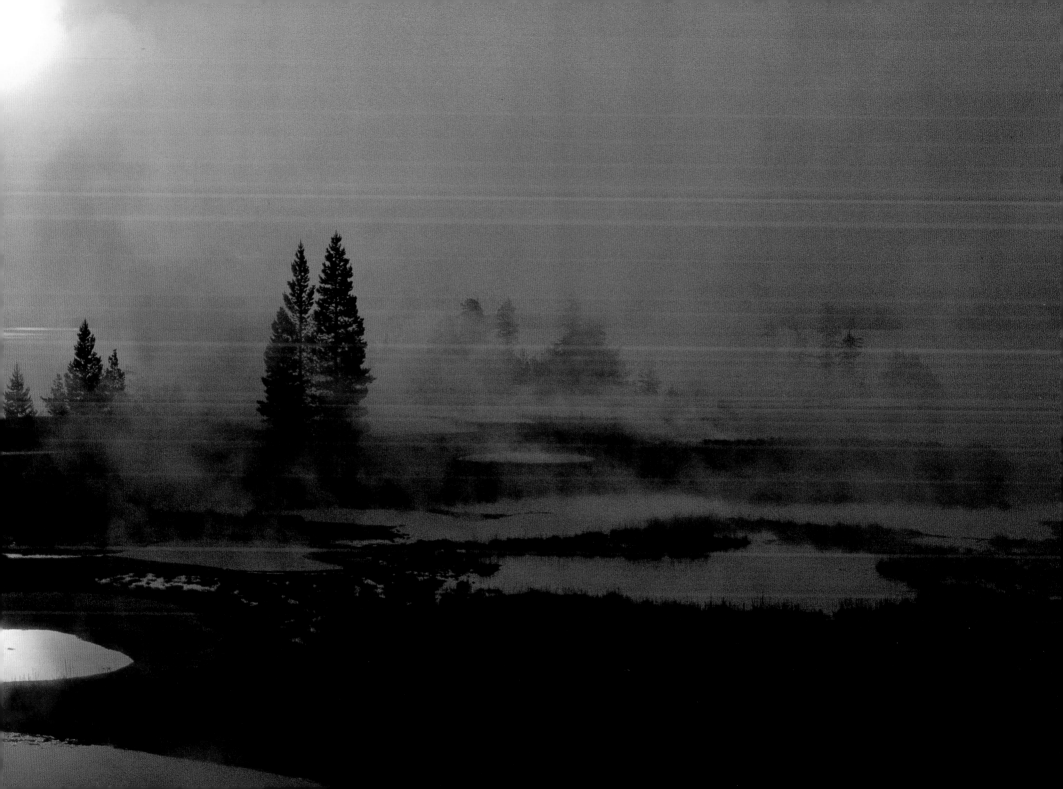

54

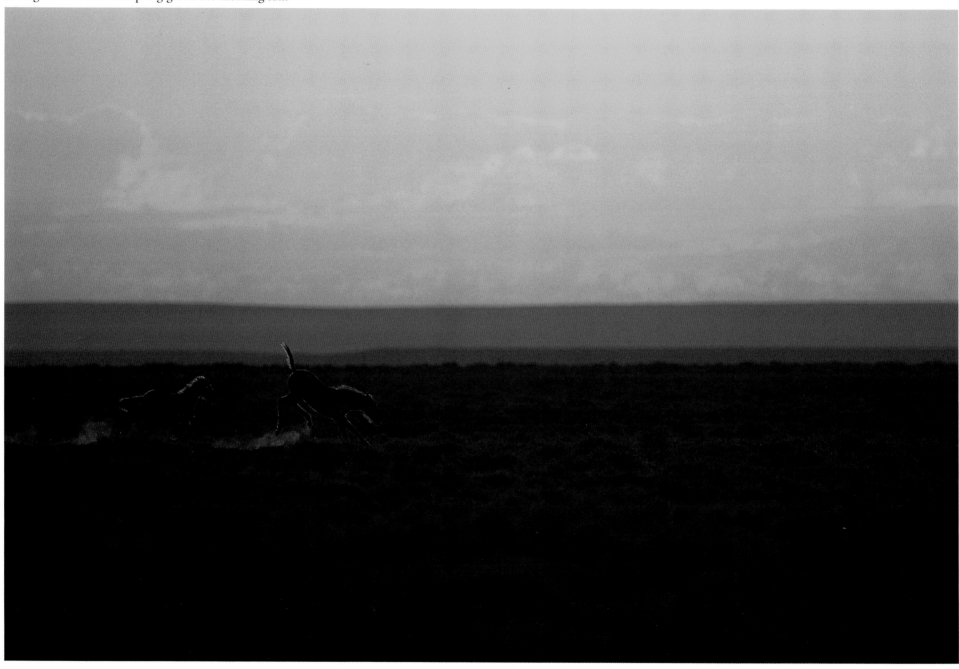

Wild horses cavort in the sagebrush.

Seedskadee National Wildlife Refuge

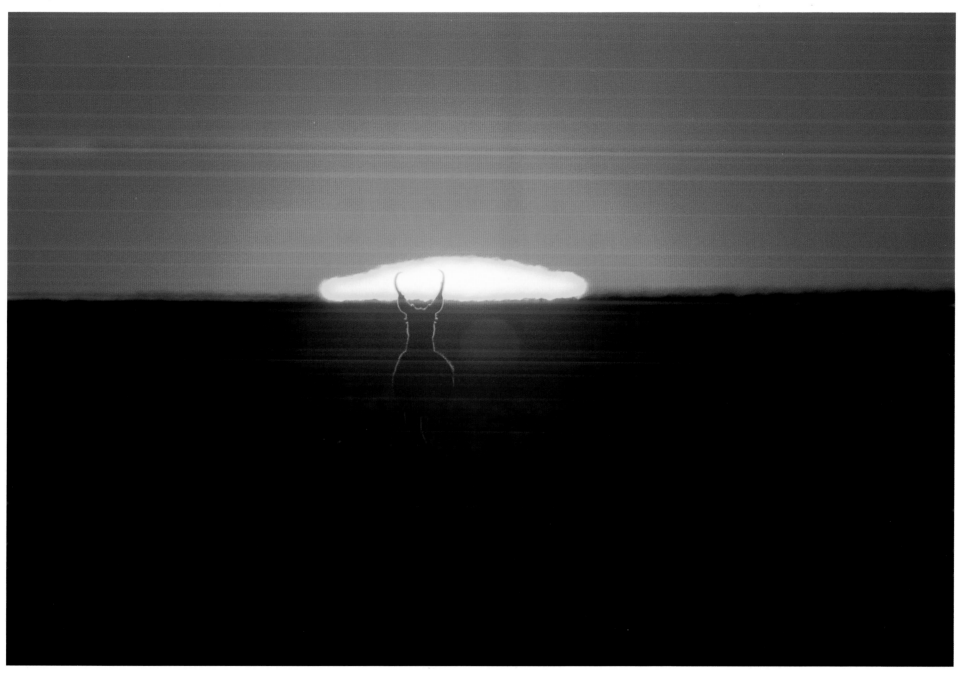

Seedskadee National Wildlife Refuge

The sun appears impaled on the pronghorn's antlers.

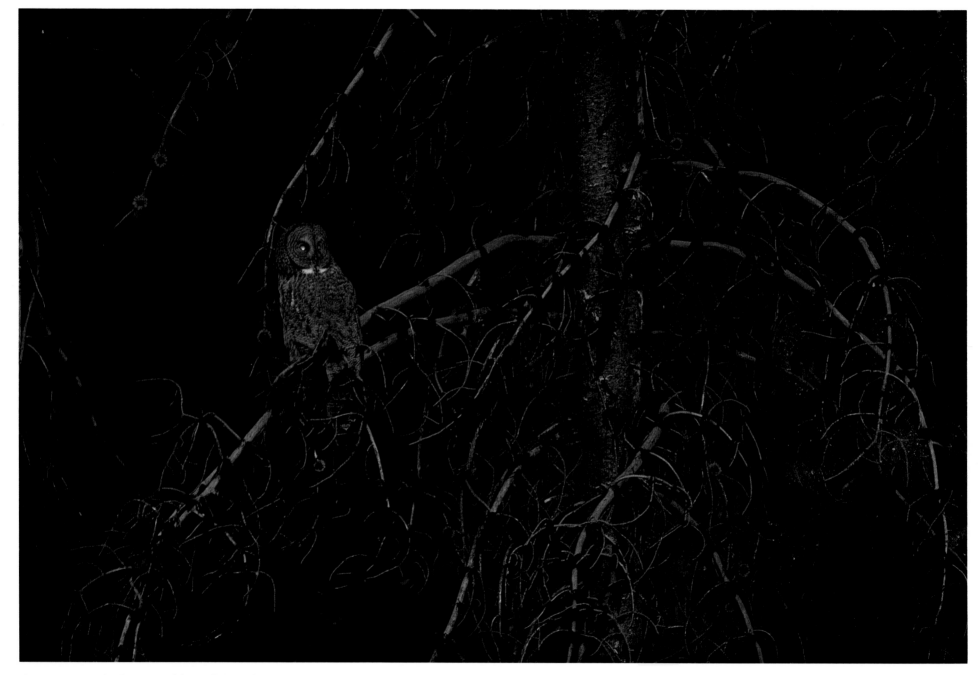

A great gray owl is but one of the night's predators.

Yellowstone National Park

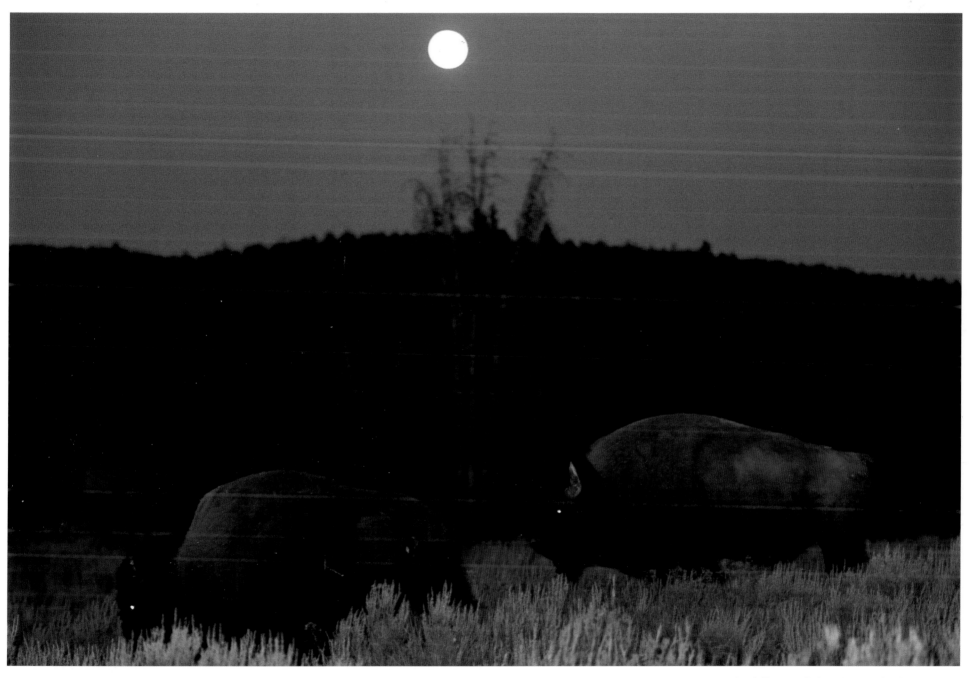

Yellowstone National Park

The full moon lights the way for these bison.

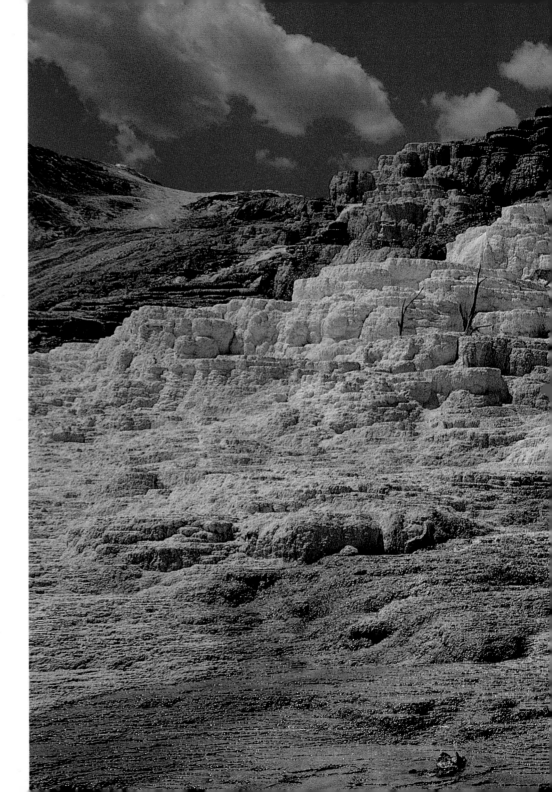

58

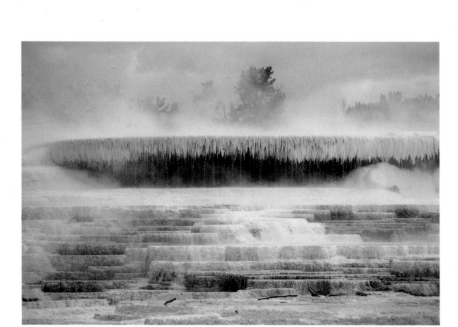

Yellowstone National Park

Mammoth Hot Springs is one of
the many hot pools within the park.

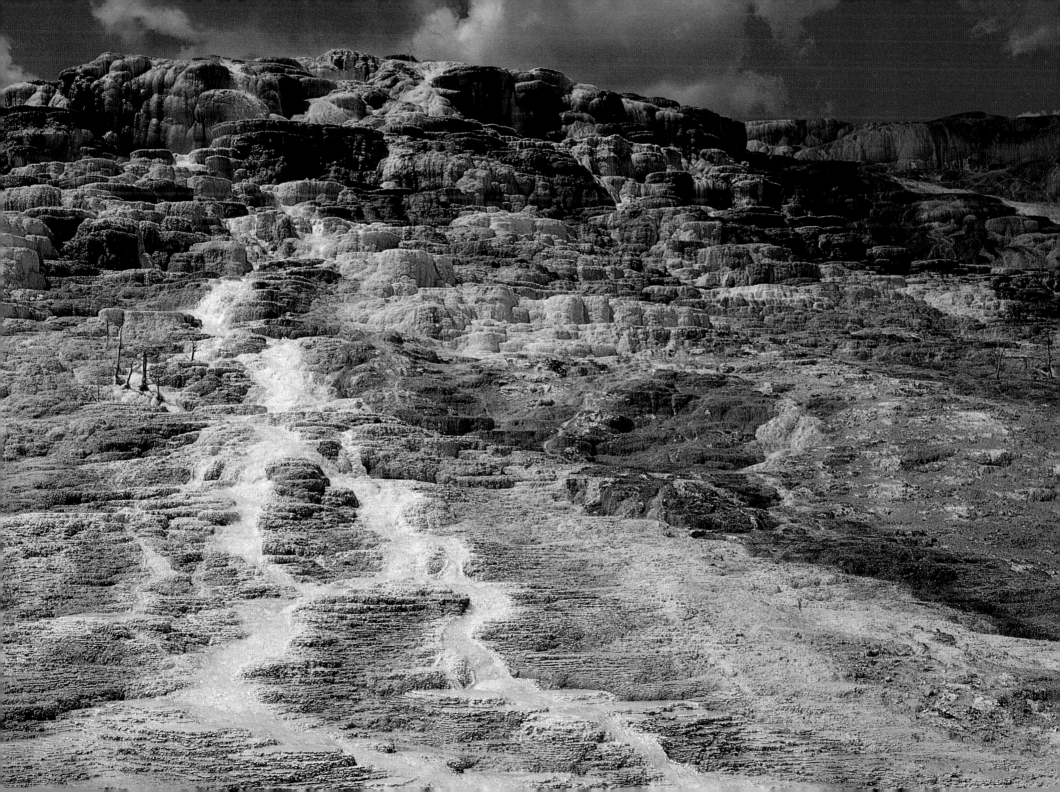

60

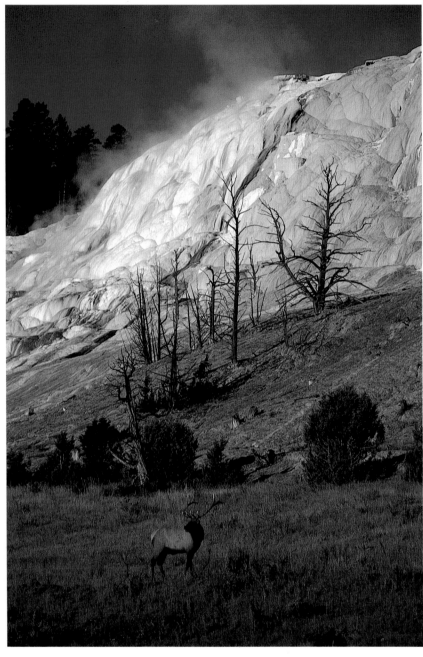

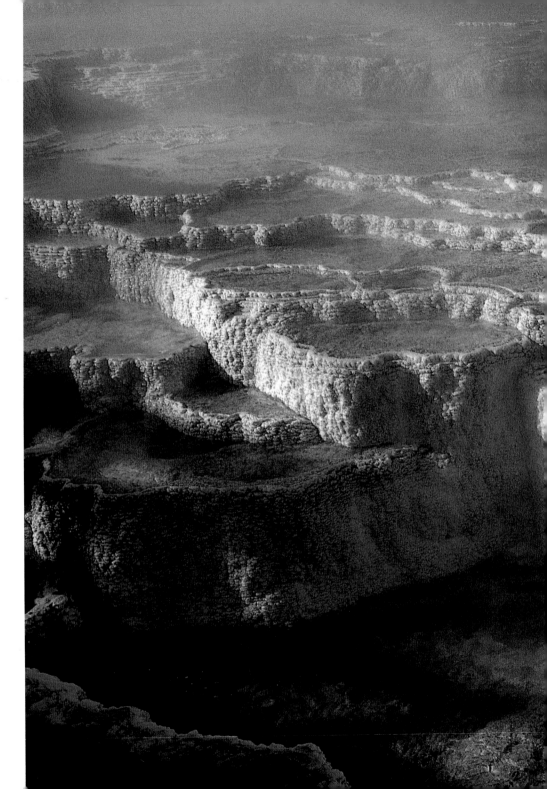

Yellowstone National Park The elk's beauty is accented by the unusual
formations of Terrace Mountain.

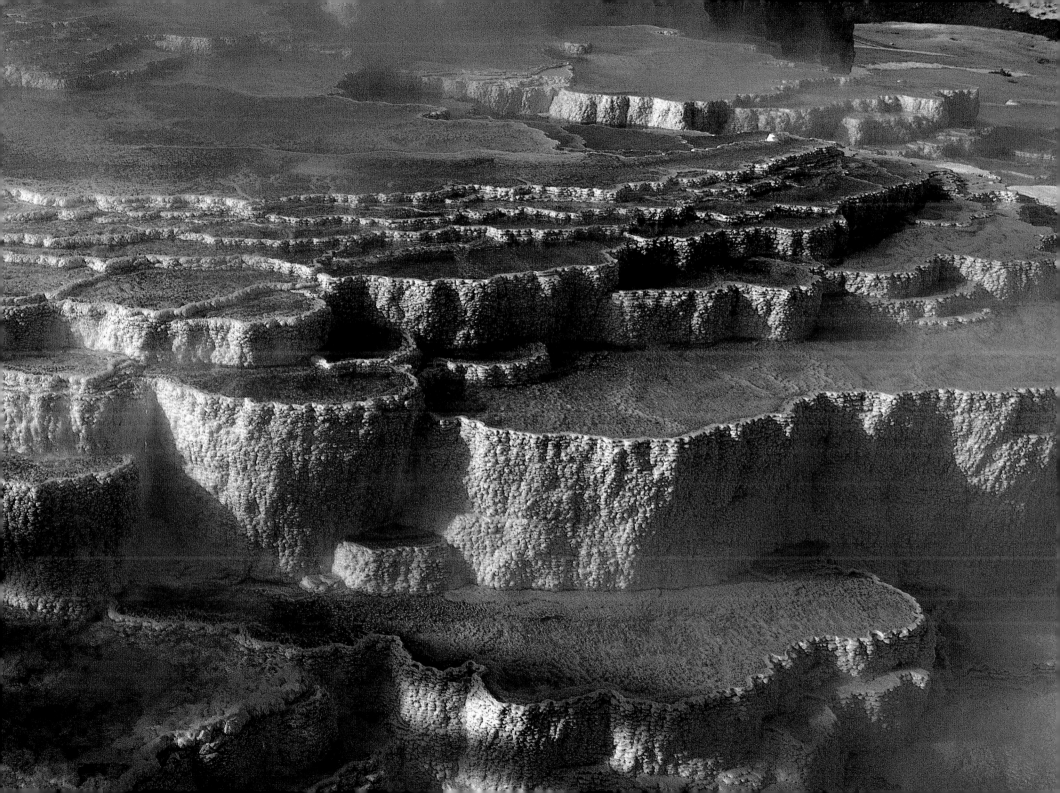

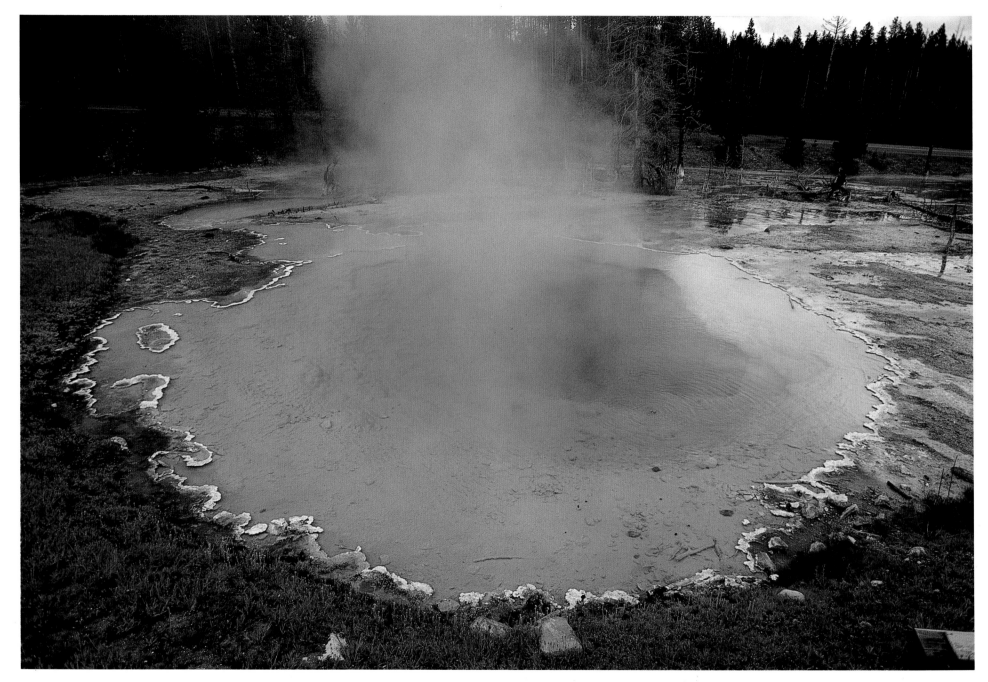

62

The hot air flowing from deep within the earth condenses quickly in the cool mountain air.

Yellowstone National Park

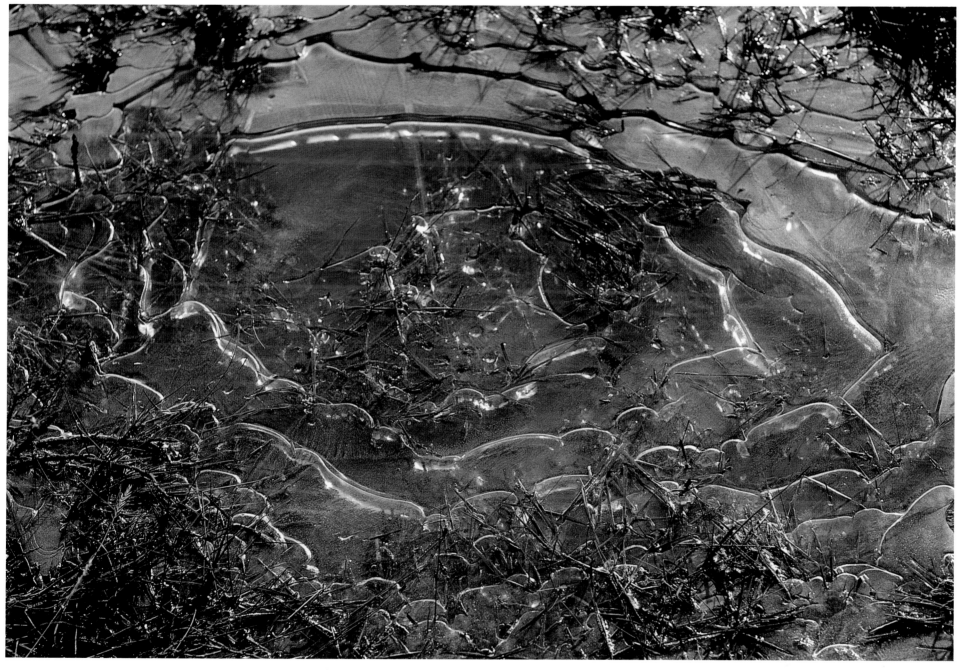

63

Grand Teton National Park

A symphony in ice.

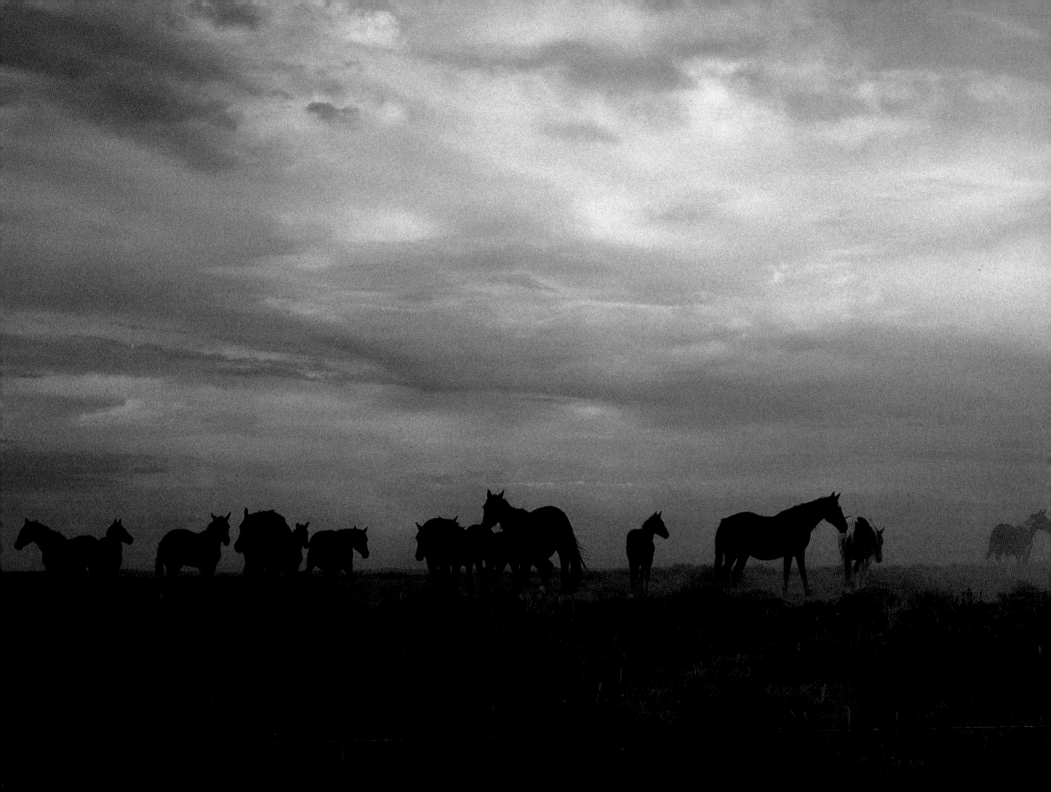

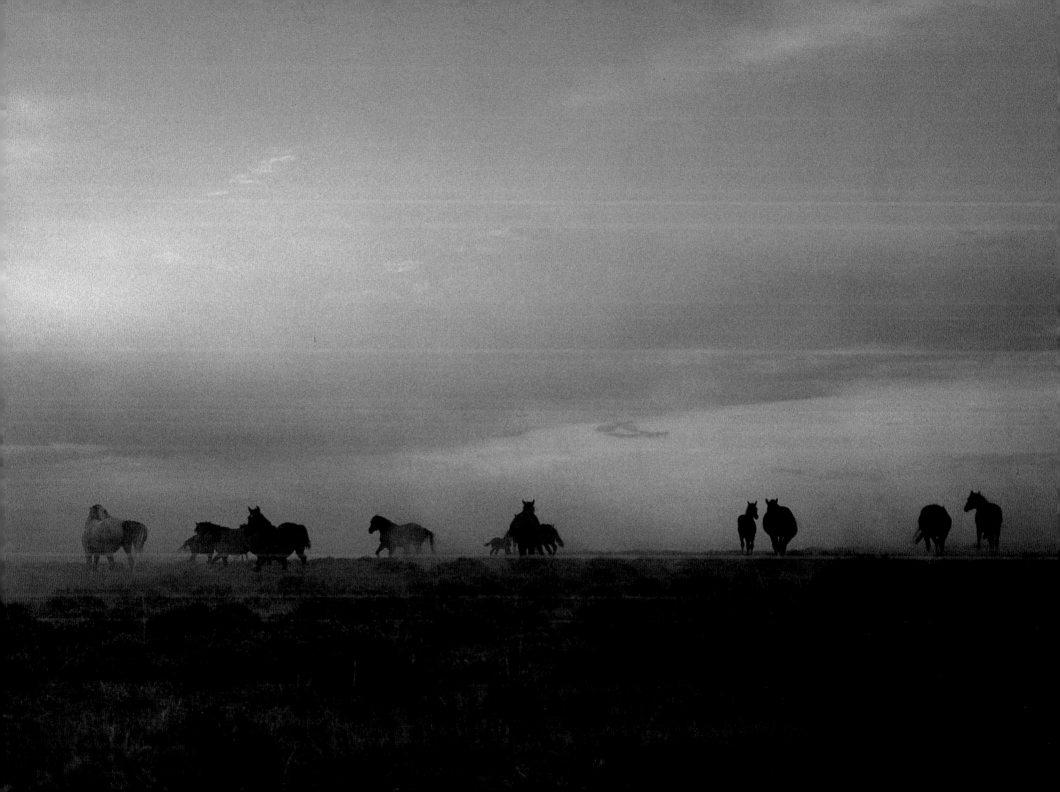

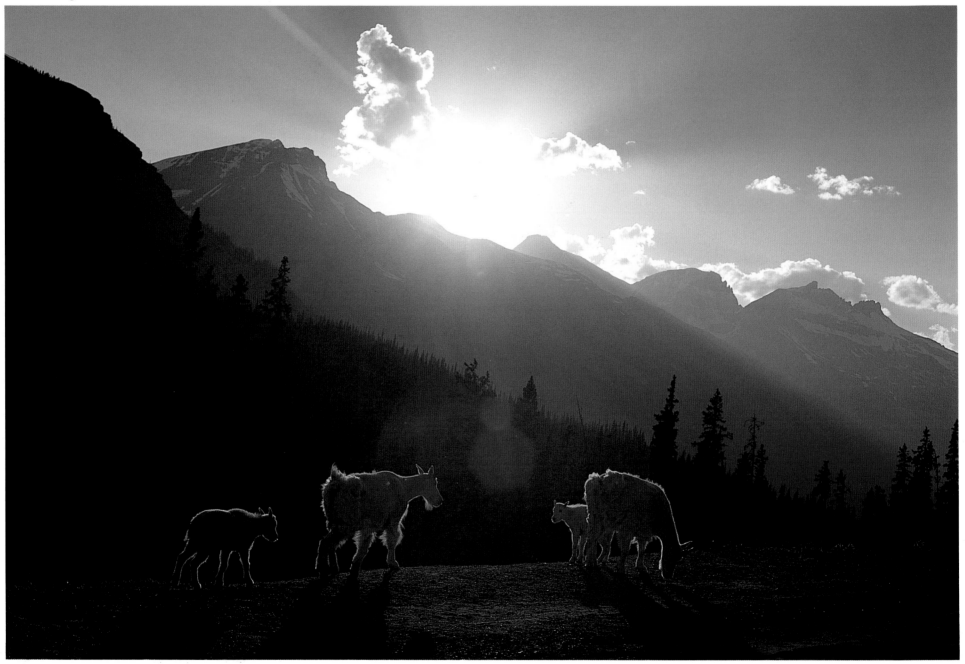

Mountain goats follow the setting sun into a gorge.

Jasper National Park

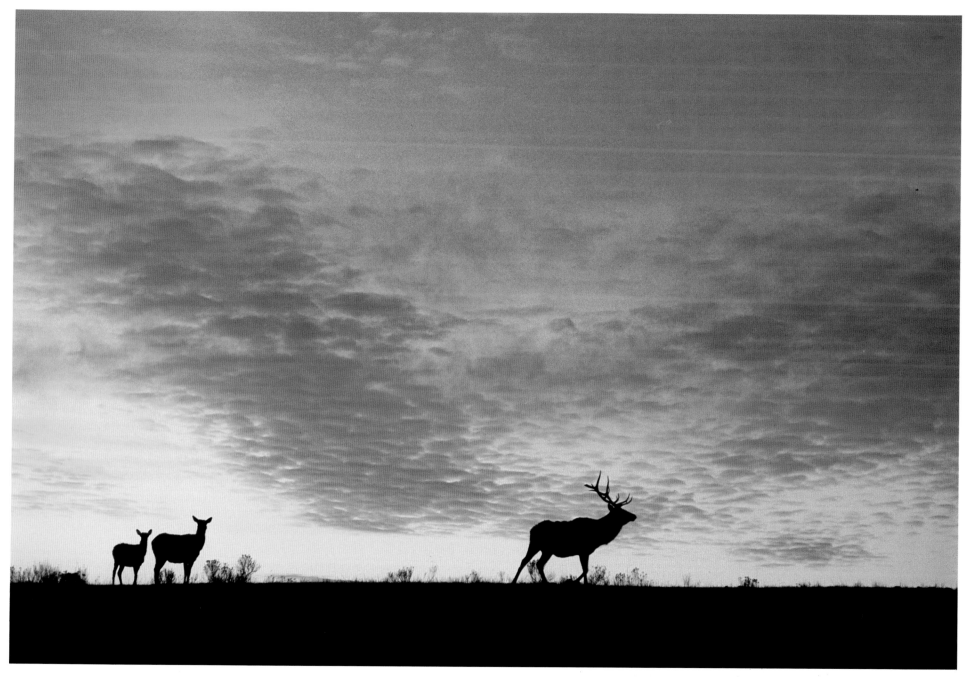

Yellowstone National Park

Elk silhouetted against the sunrise.

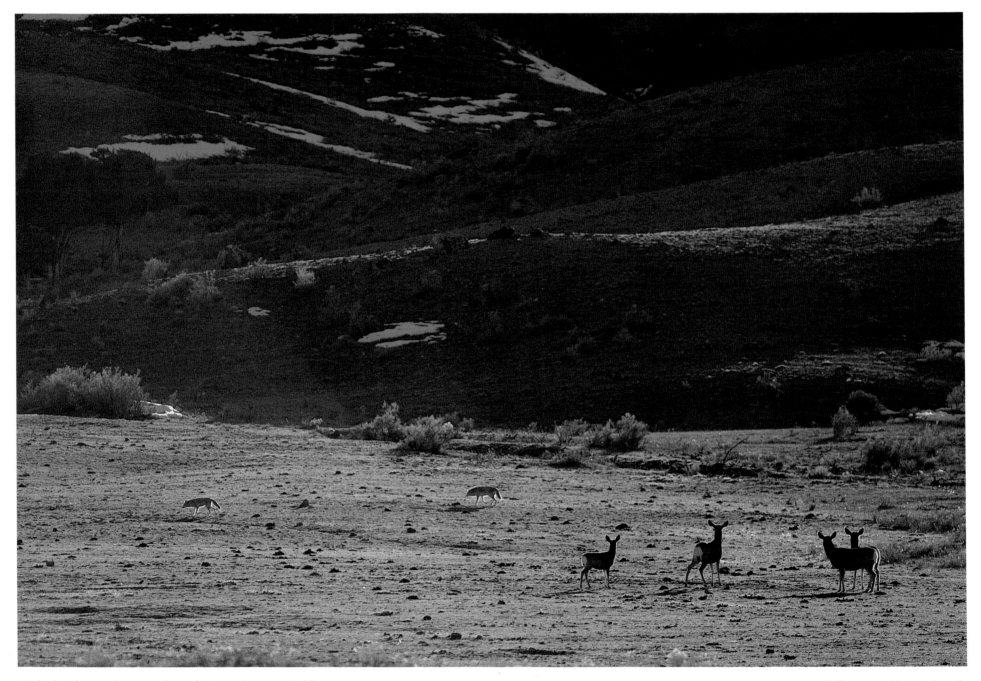

68

Mule deer keep a sharp watch on their carnivorous neighbors.

Yellowstone National Park

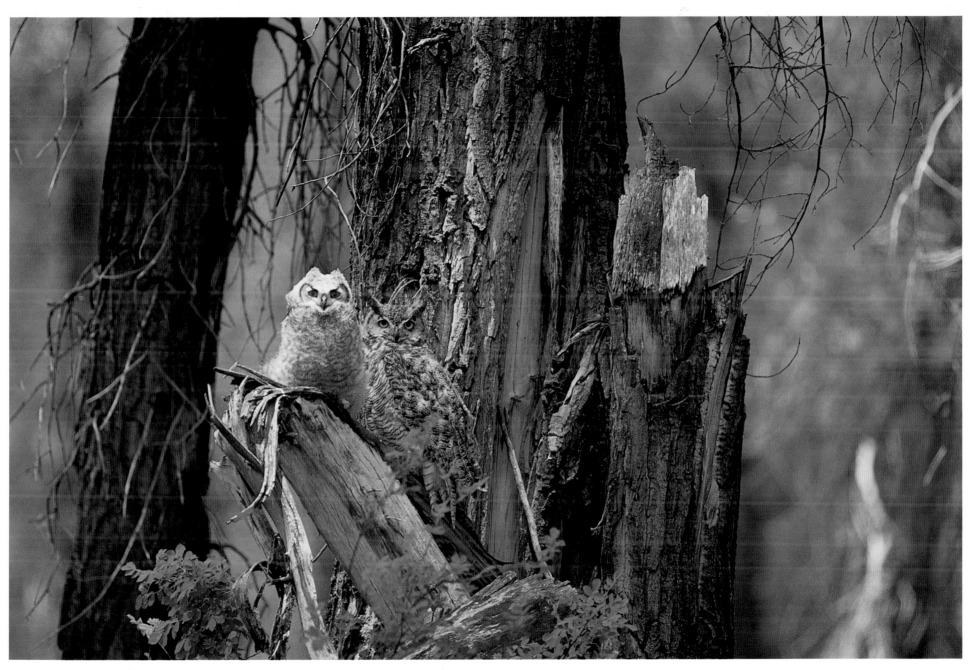

Near Jackson Hole, Wyoming

The adult great horned owl is nearly invisible in its camouflage; the young bird's vulnerability is evident.

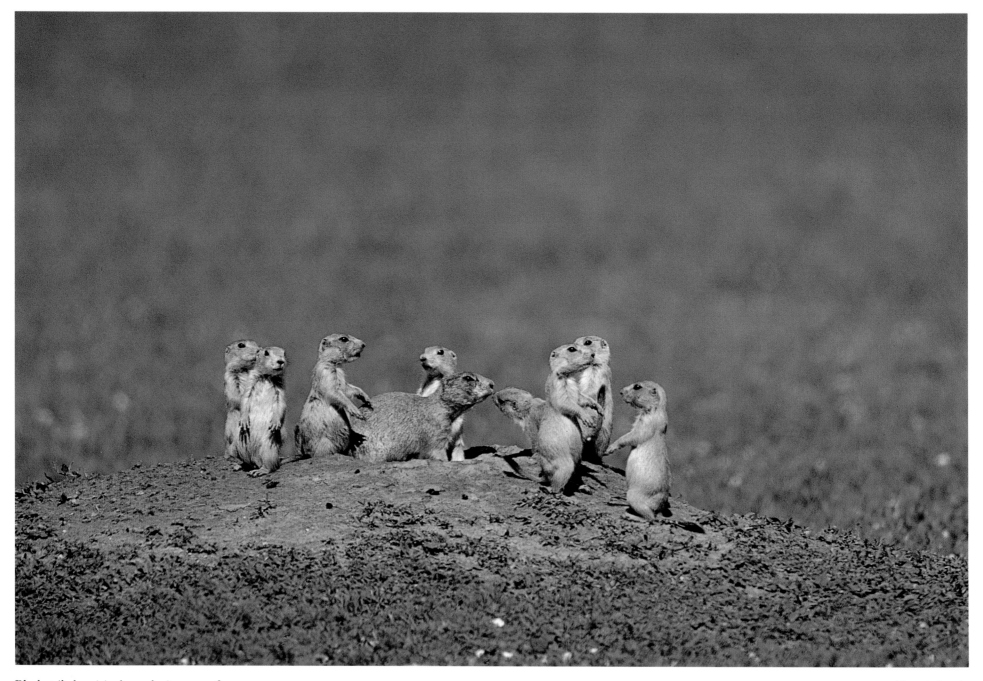

Black-tailed prairie dogs take in some afternoon sun.

Near Boulder, Colorado

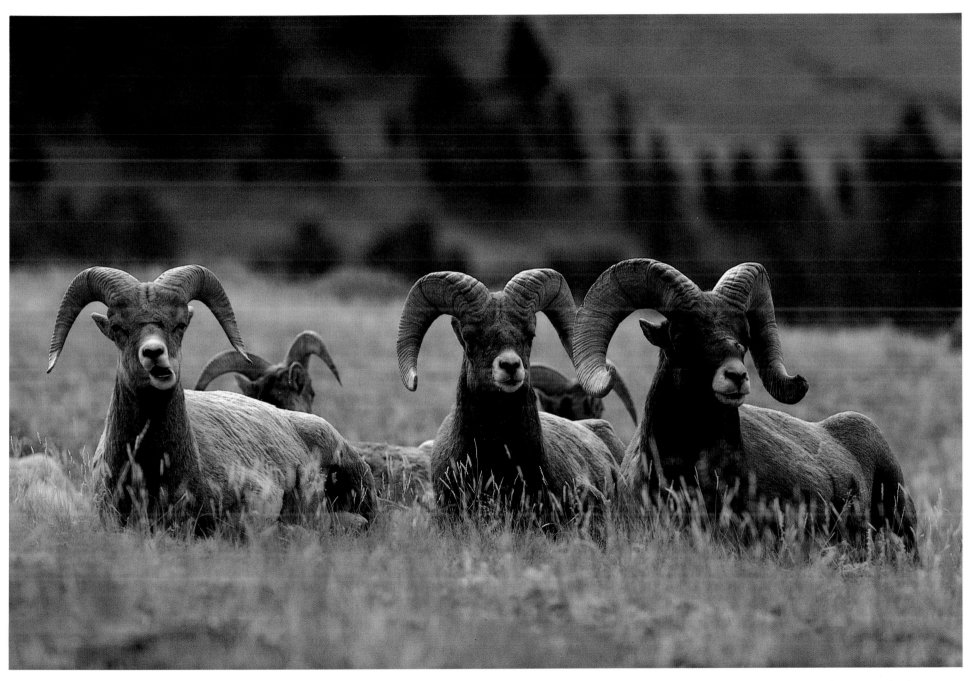

Yellowstone National Park

It is easy to see how the bighorn sheep came by their name.

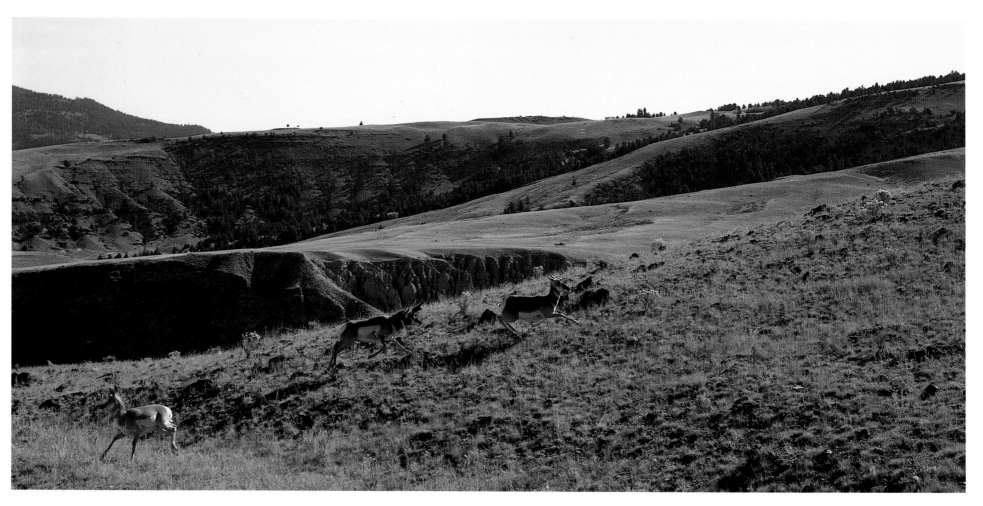

A male pronghorn pursues a female in the annual mating rite.

Yellowstone National Park

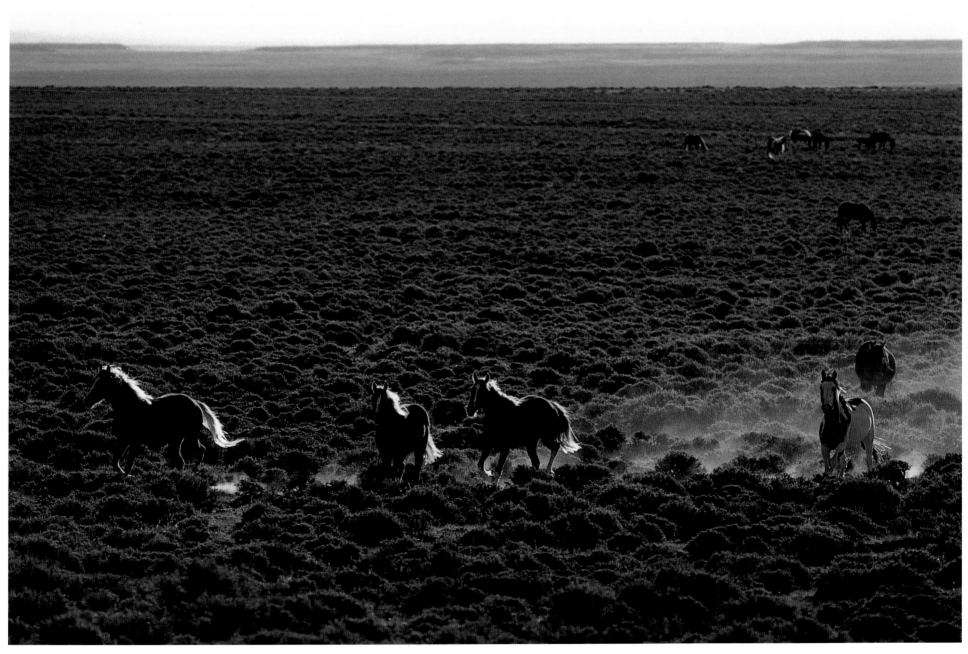

73

Seedskadee National Wildlife Refuge

Free-spirited horses raise pale clouds of dust.

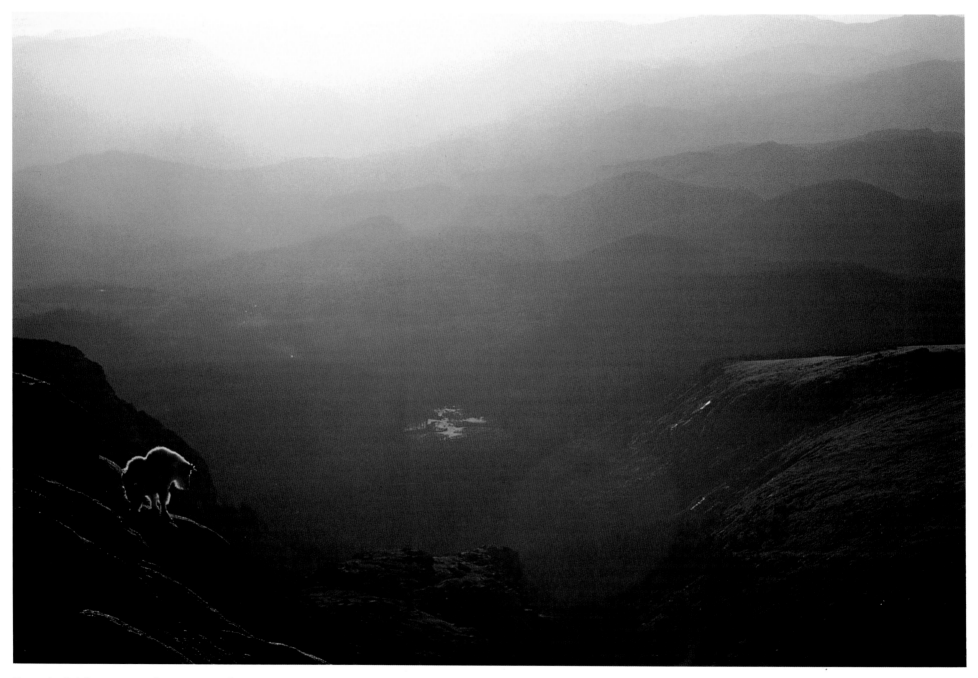

From the heights, a mountain goat greets the morning.

Rocky Mountains, Colorado

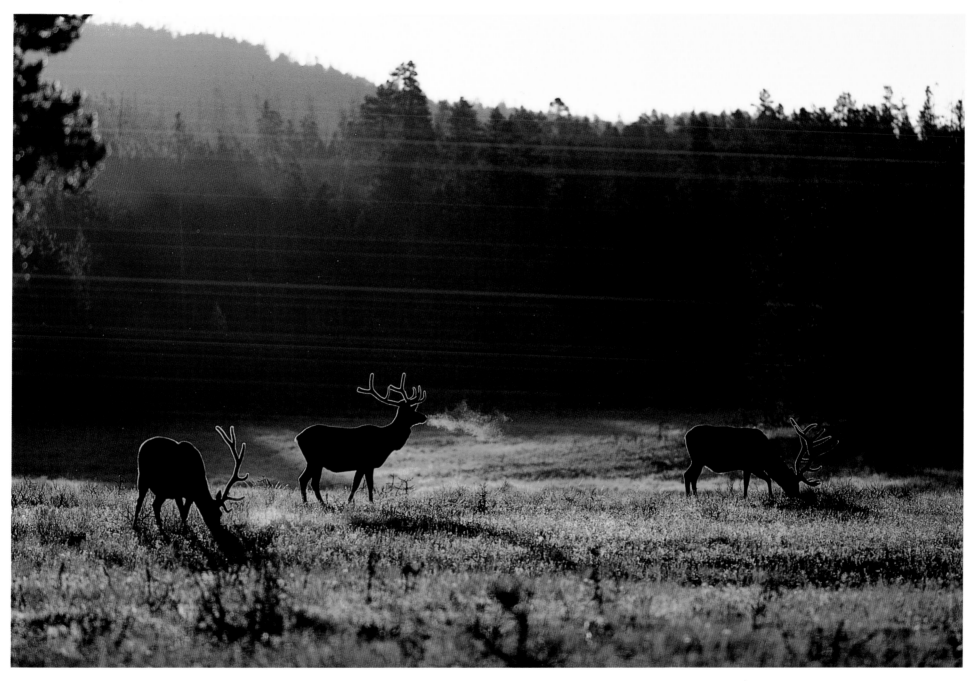

Yellowstone National Park The velvet covering on the elk's antlers is a sign that it is still summer. Only in the fall, when the fights begin, will the antlers be strong and bare.

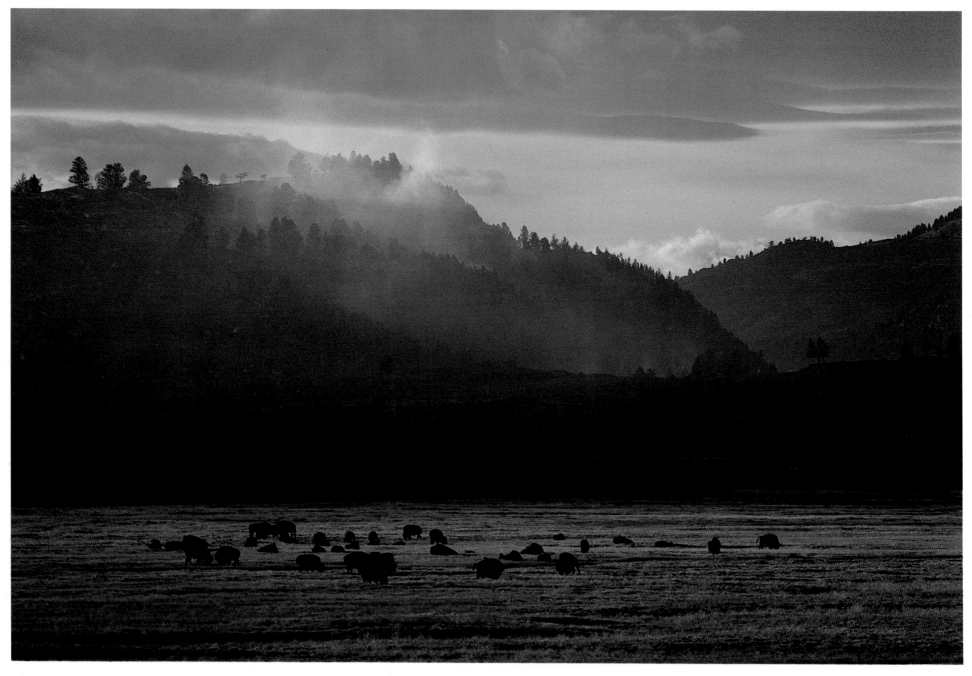

These bison are gathered below a ridge still marked by the effects of a great fire.

Yellowstone National Park

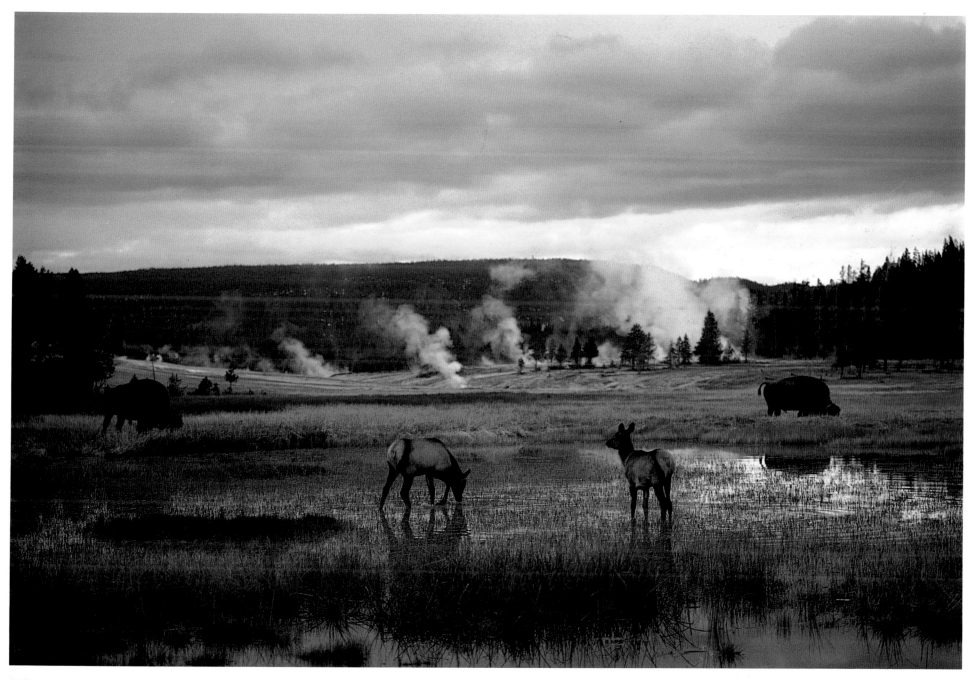

Yellowstone National Park

The steam issuing from the earth adds an eerie beauty to the landscape.

The coyote's color blends well with its environment.

Yellowstone National Park

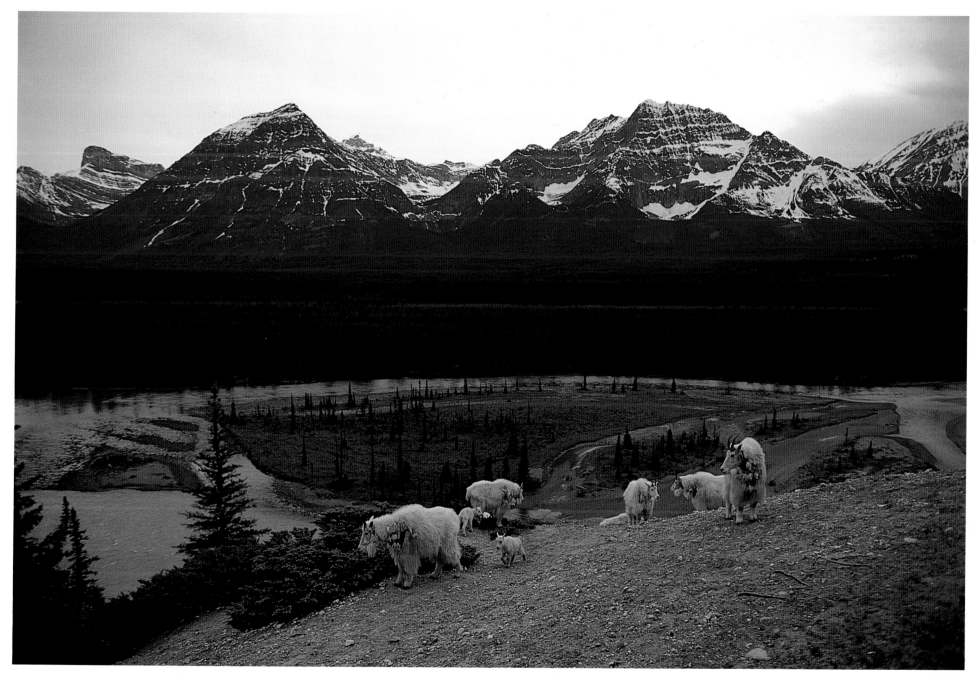

Jasper National Park

The animals are in harmony with their mountain world.

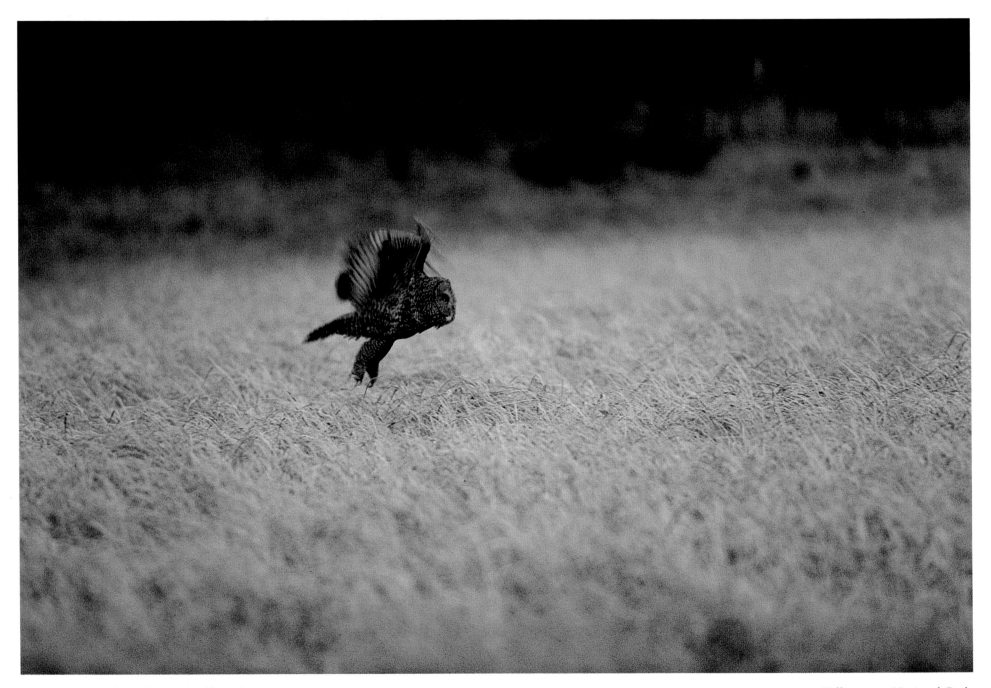

The great gray owl is a silent and swift predator.

Yellowstone National Park

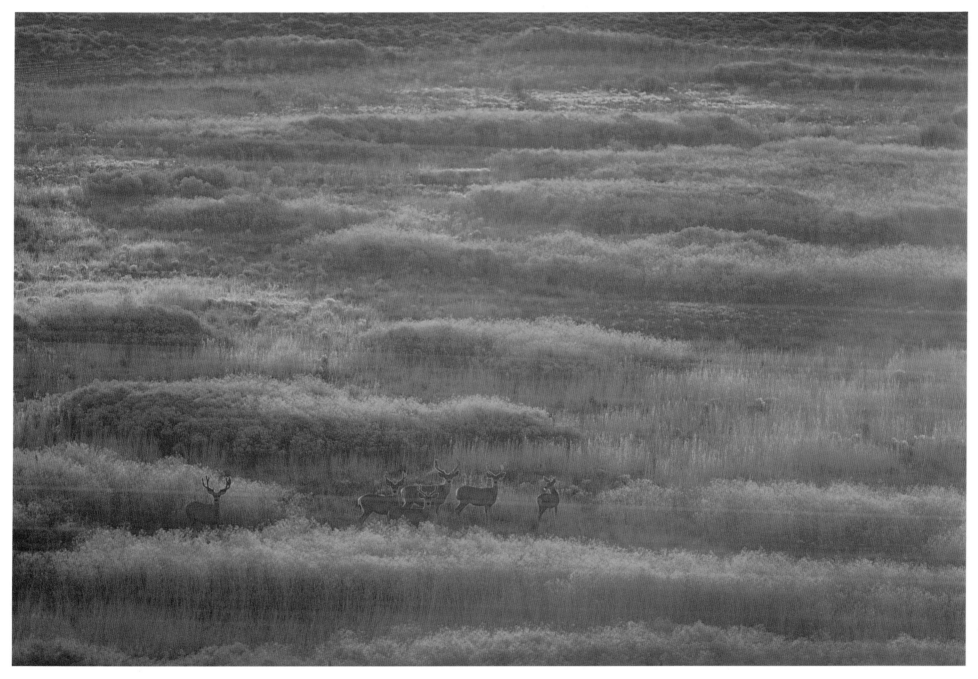

81

Seedskadee National Wildlife Refuge

Mule deer, alert to an unfamiliar sound.

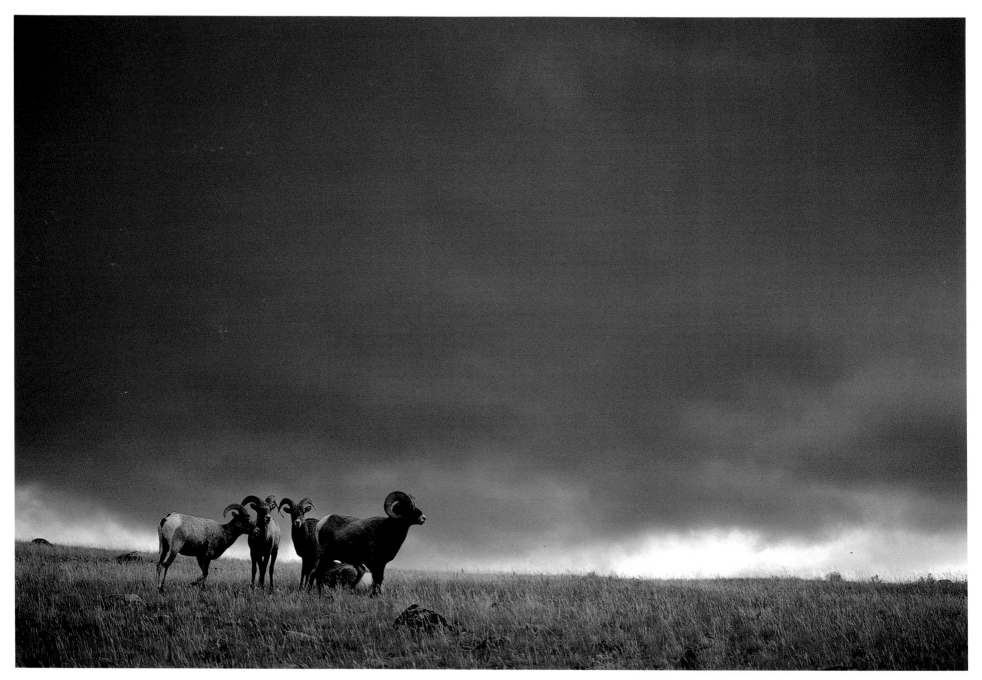

The black clouds carry the promise of another hard winter.

Yellowstone National Park

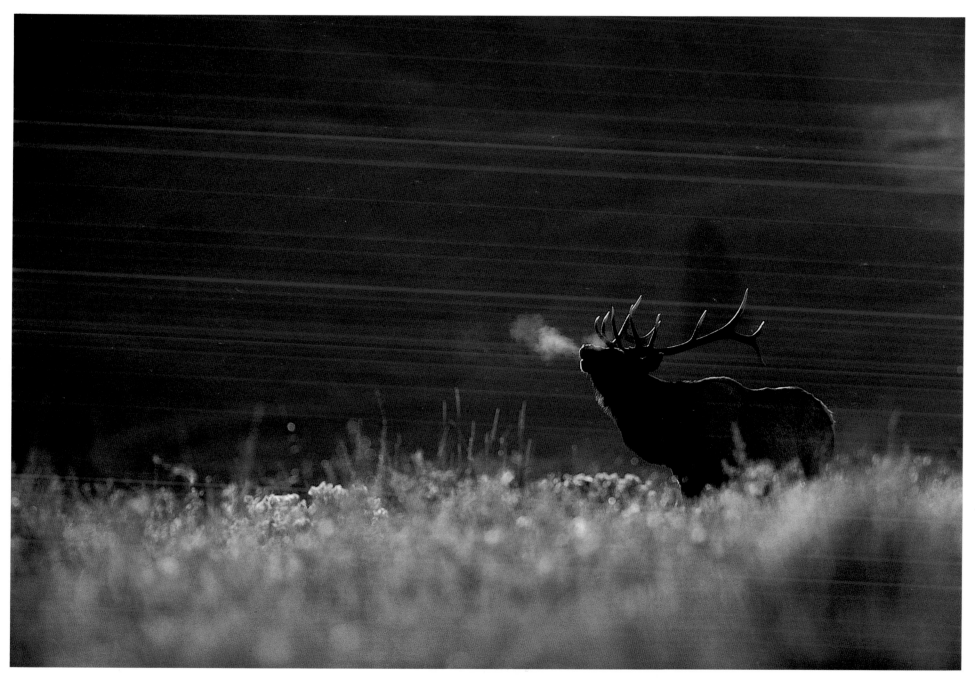

Yellowstone National Park

An elk calls out a challenge in the cold air.

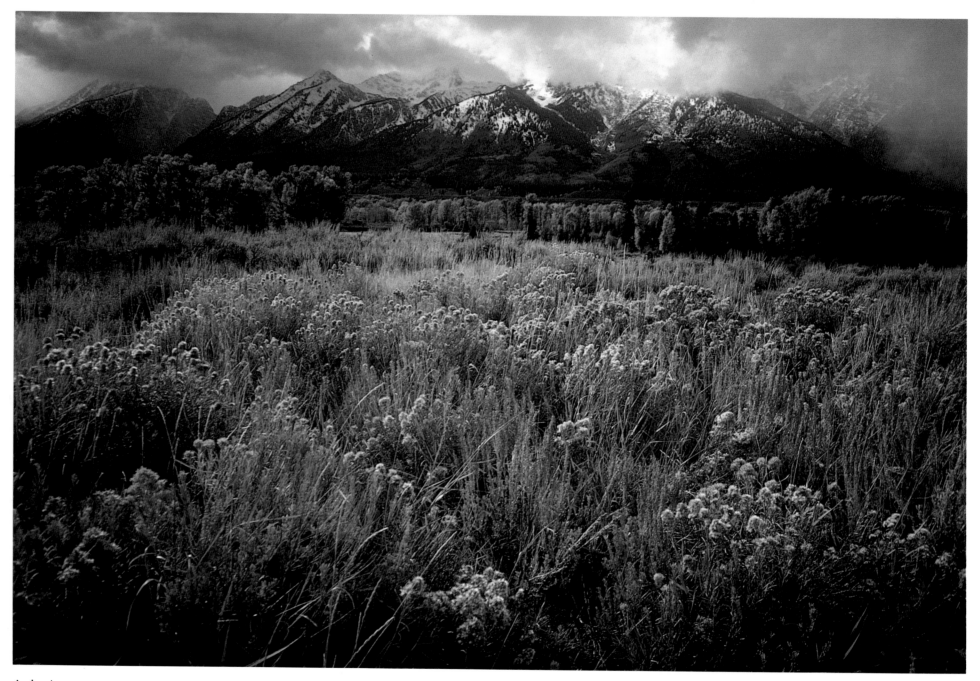

84

A clearing storm.

Grand Teton National Park

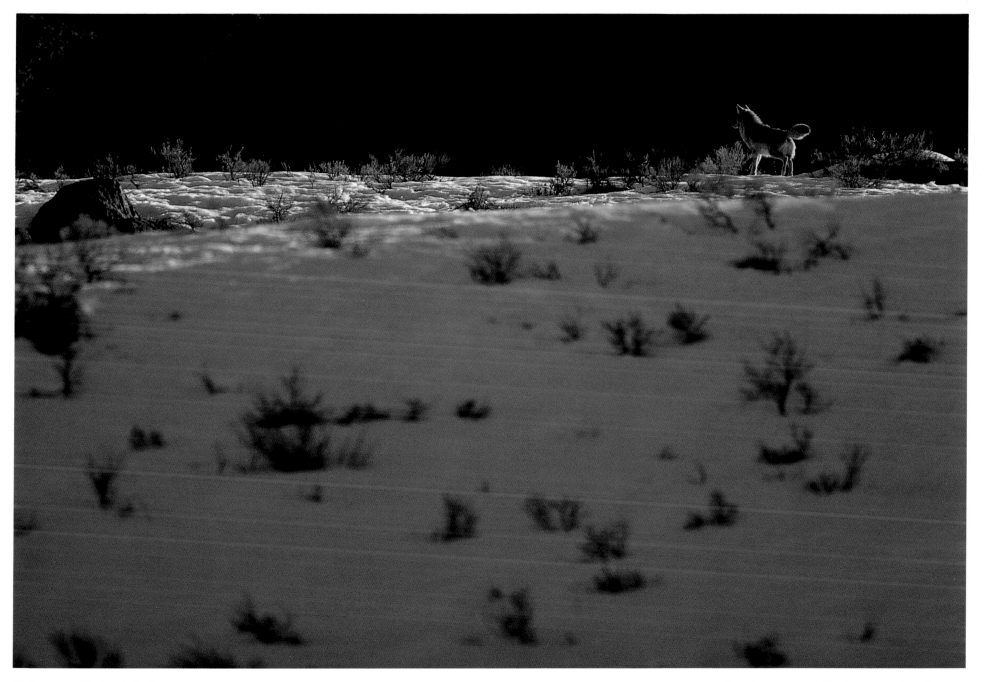

85

Yellowstone National Park

Hunting is more difficult on a blanket of snow.

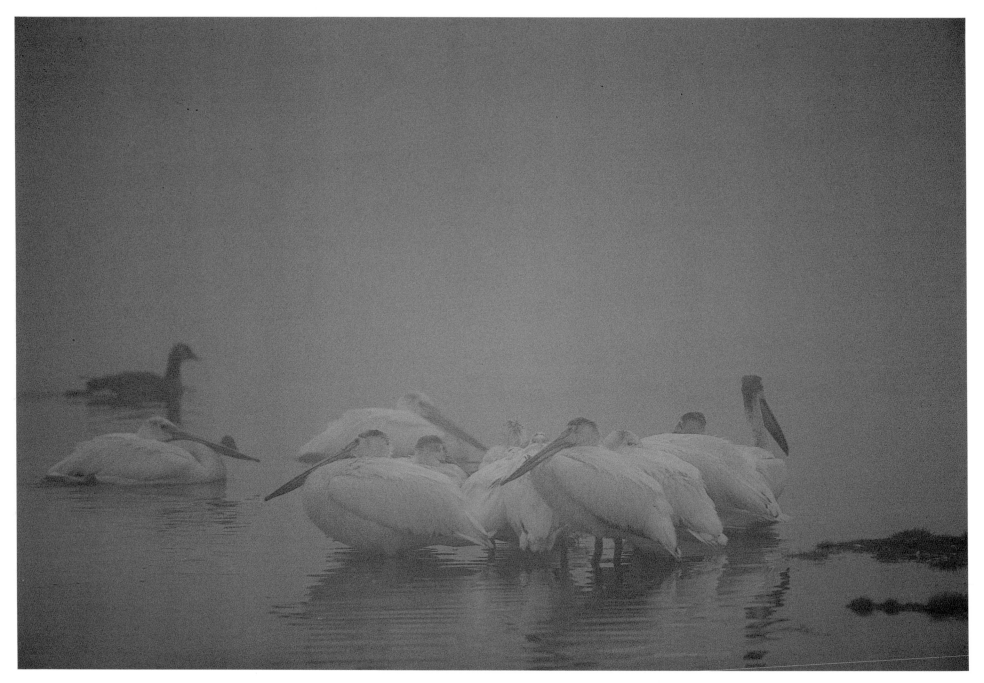

American white pelicans huddle together against a chilly mist.

Yellowstone National Park

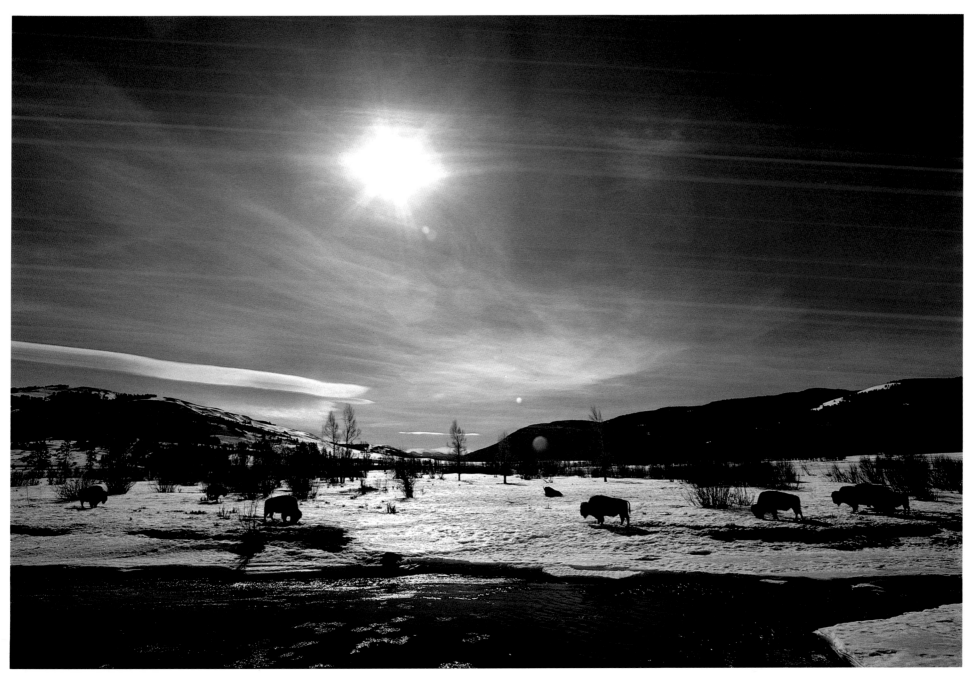

Yellowstone National Park

Bison rummage for plants beneath the snow.

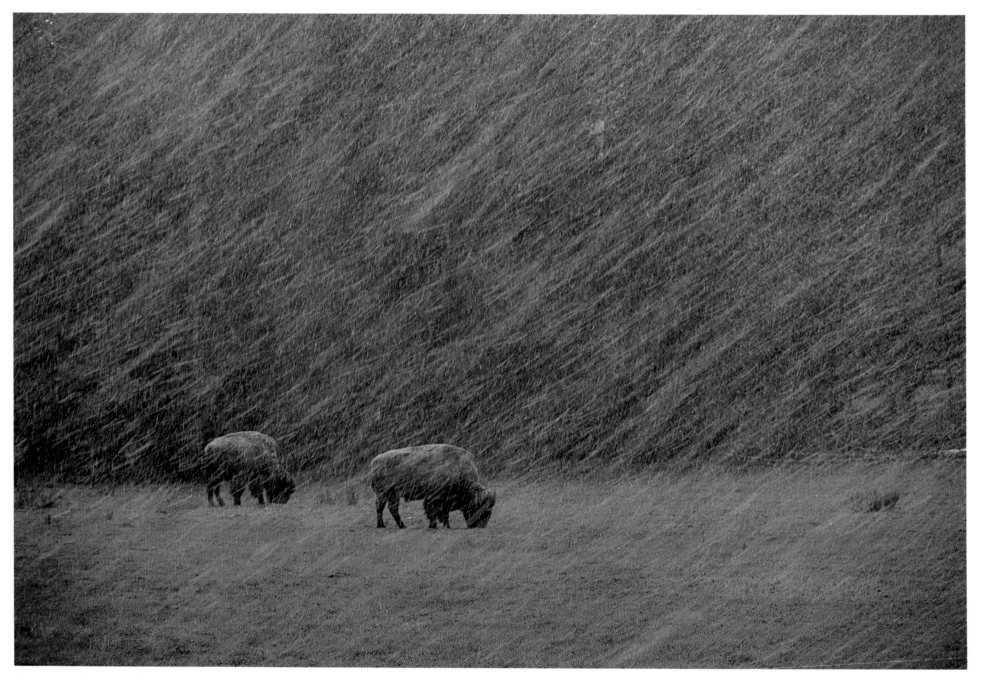

88

Intent upon their meal, two bison ignore a spring snowstorm.

Yellowstone National Park

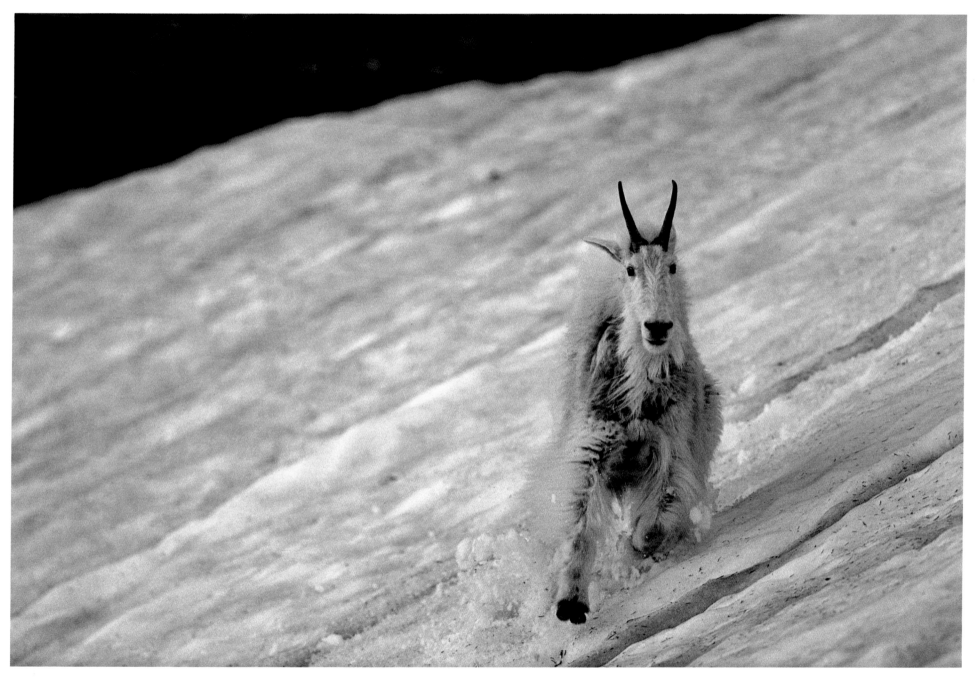

89

Glacier National Park Although they usually move rather slowly, mountain goats are capable of great speeds when the occasion demands it.

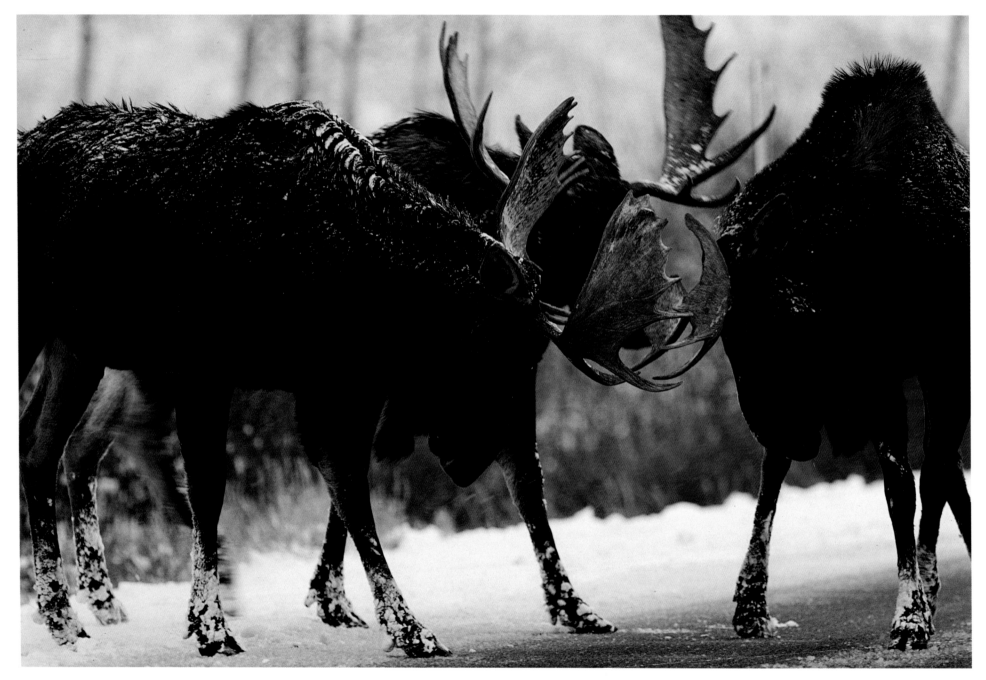

90

Three moose attempt to assert their dominance.

Grand Teton National Park

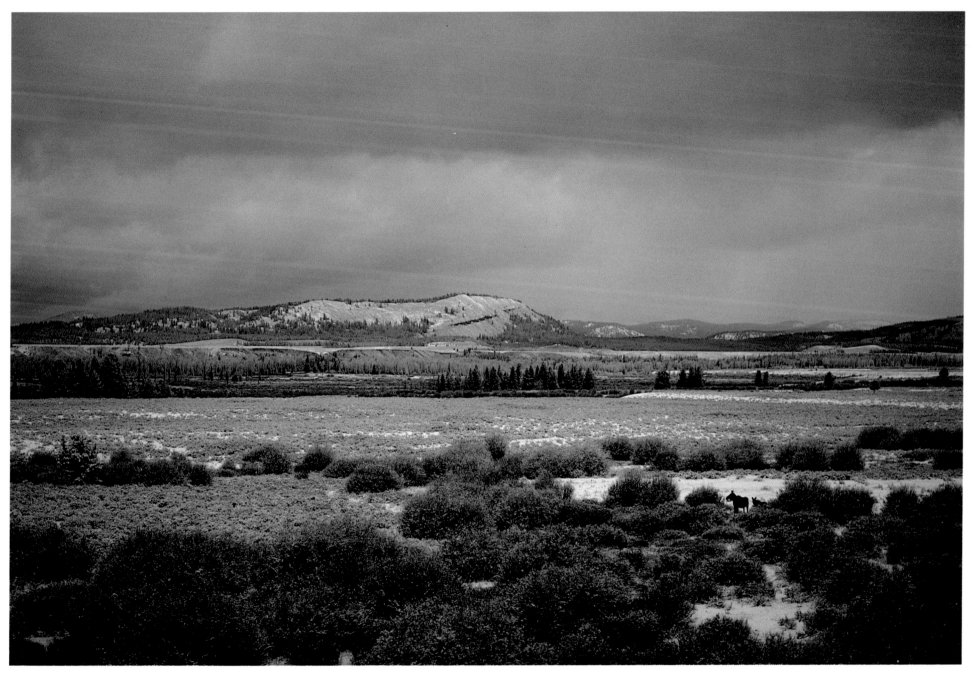

Grand Teton National Park

A moose and her calf contemplate the first snows of winter.

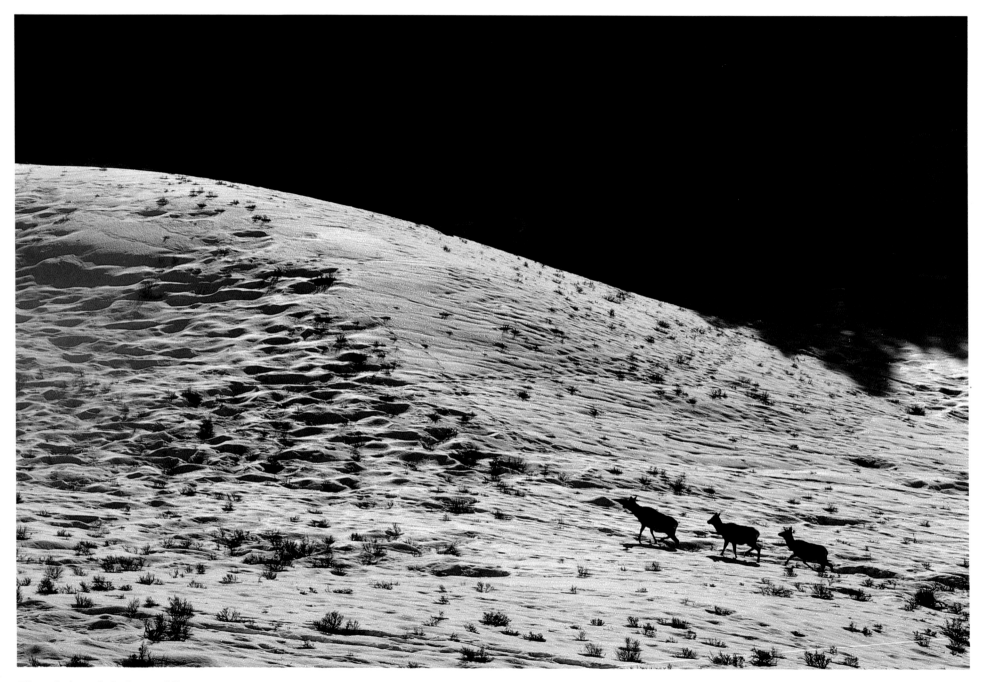

Elk push through fresh snowfall.

Yellowstone National Park

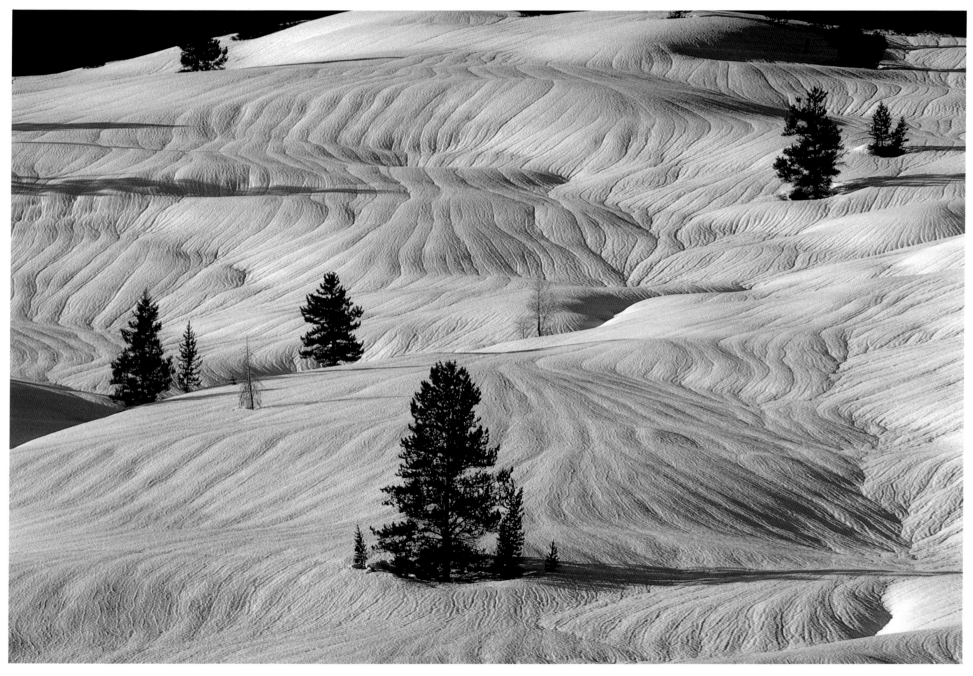

Near Jackson Hole, Wyoming

93

Patterns wrought by wind and sun.

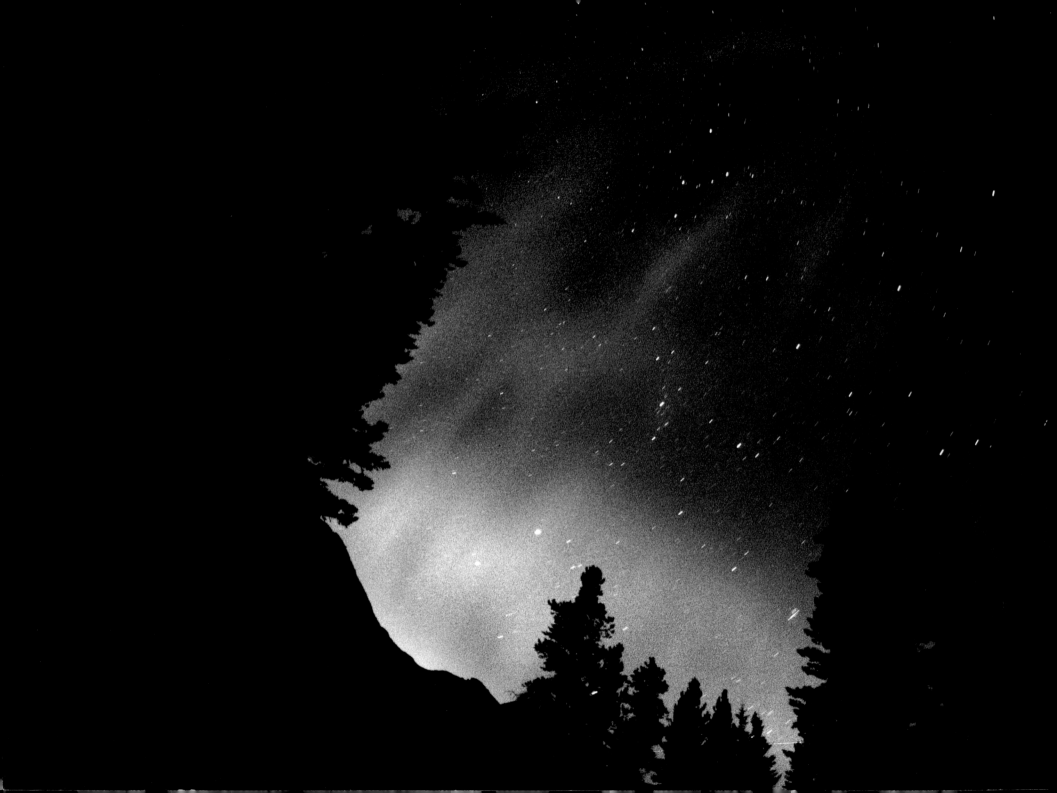